The Beginner's Guide

Human Anatomy

An artist's step-by-step guide to techniques and materials

James Horton

NEW HOLLAND

First published in 2002 by
New Holland Publishers (UK) Ltd
London • Cape Town • Sydney • Auckland

Garfield House, 86–88 Edgware Road
London W2 2EA
United Kingdom
www.newhollandpublishers.com

80 McKenzie Street
Cape Town 8001
South Africa

Level 1, Unit 4, 14 Aquatic Drive
Frenchs Forest, NSW 2086
Australia

218 Lake Road
Northcote, Auckland
New Zealand

1 3 5 7 9 10 8 6 4 2

ISBN 1 84330 057 5

Designed and edited by
Axis Design Editions Limited
8 Accommodation Road
London NW11 8ED

Art Director: Siân Keogh
Managing Editor: Michael Spilling
Art Editor: Juliet Brown
Photographer: David Jordan
Senior Editor: Clare Hubbard
Production: Hazel Kirkman

Reproduced in Singapore by Pica Digital PTE Ltd
Printed and Bound in Malaysia by Times Offset (M) Sdn Bhd

ACKNOWLEDGEMENTS
Special thanks are due to Daler-Rowney,
P.O. Box 10, Bracknell, Berkshire, RG12 4ST
for providing the materials and equipment featured in this book.

CONTENTS

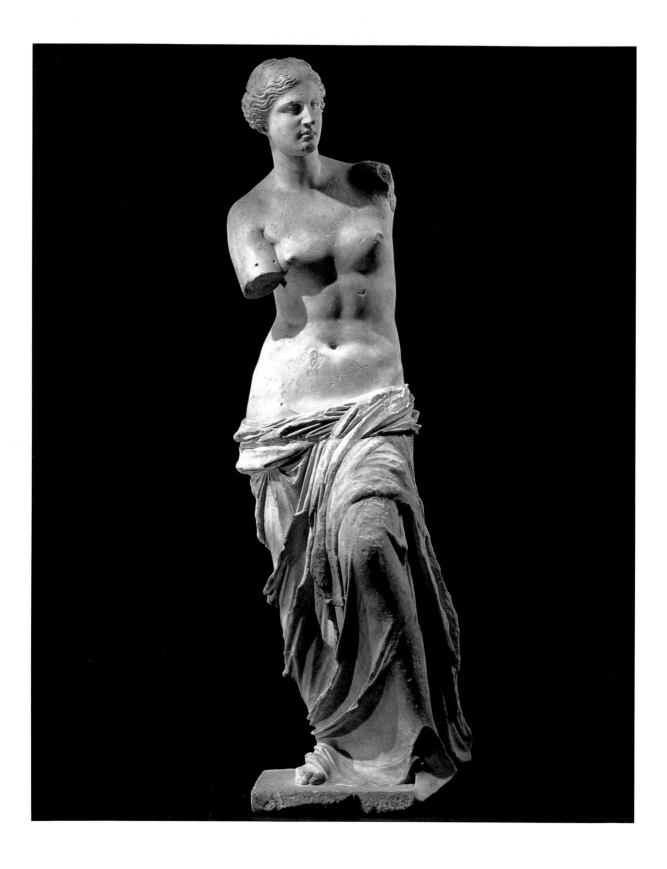

INTRODUCTION

The human figure has been an important part of world art since the first prehistoric attempts to create images. At the zenith of their cultural and artistic achievements, the Ancient Greeks (7th–5th century BC) made great advances in the depiction of the human form. Sculpture was then the most important medium, and those carvings and bronzes that have survived demonstrate the Greeks' great skill.

Among the works of Pheidias, who lived in the 5th century BC, are the two great sculptures of Athene and Zeus in Olympia. Pheidias's work demonstrates the Greeks' understanding of how the human body worked – and how it should be represented.

We can recognize similar contemporary criteria for the perfect muscular male form also esteemed in Ancient Greece. However, the criteria for the female form has differed throughout history, and is certainly different now compared to when the Greeks created

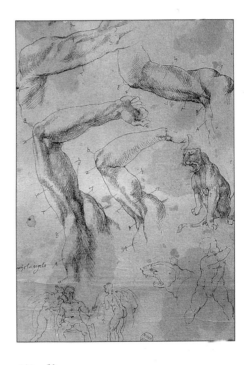

Arms Studies
Michelangelo Buonarroti (1475–1564)

Michelangelo's many anatomical studies gave him an excellent eye for the human form.

their works of art. The *Venus de Milo* for example – a 1st-century BC Greek statue discovered on the island of Melos in 1820 – shows that the ideal woman of that time was of a fuller build than is idealized in our modern society.

Venus de Milo
Greek, 1st century BC

This famous statue, which resides in the Louvre Museum in Paris, is an example of the advanced anatomical knowledge of the Ancient Greeks.

In the Rome of antiquity (750 BC–AD 500), athletes, warriors, soldiers and gladiators were all at the heart of Roman culture and there are many sculptures from Roman times that bear witness to the importance of physical perfection.

The long period between the end of the Roman empire and the start of the Italian Renaissance in the 14th century produced

Valpincon Bather
Jean Auguste Dominique Ingres (1780–1867)

Ingres used his knowledge of anatomy to achieve near-perfection in his paintings of nudes.

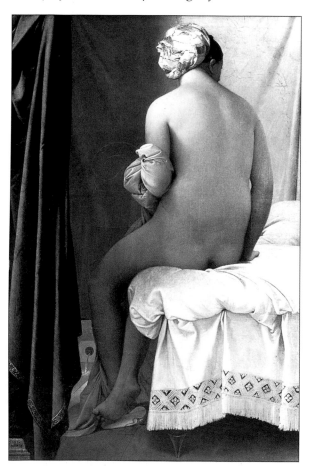

very little in artistic terms; but by the time the Renaissance was in its stride, the human form was once again at the centre of high art. As always, religion was providing an outlet for the depiction of the human form and although the worship of a Christian God was based more on the spiritual than the physical, Christ was in the main portrayed as a well-built man. Indeed, most characters portrayed in Renaissance paintings are shown with well-nourished bodies.

It was at this time that there began a more scientific inquiry into the workings of the human body, which extended into the dissection of corpses. Michelangelo (1475–1564), for example, risked a death sentence when he secretly dissected a human body by candlelight, in order to extend his anatomical knowledge. Interfering with dead people was illegal at that time – even if the purpose was a search for knowledge.

Leonardo da Vinci (1452–1519), the quintessential Renaissance man, made a whole series of anatomical drawings from a flayed figure to further medical knowledge as much as that of art.

During the Italian Renaissance, the study of anatomy assumed great importance. Paintings were full of characters wearing little or no clothing. In the early stages of composition the artist would envisage a variety of poses from his imagination, establish the scene with the relationship of one figure to another and then require the models to enact the scene for the final work.

As studio practice, this continued until the 19th century, but with the start of the Romantic period in the late 18th century, the

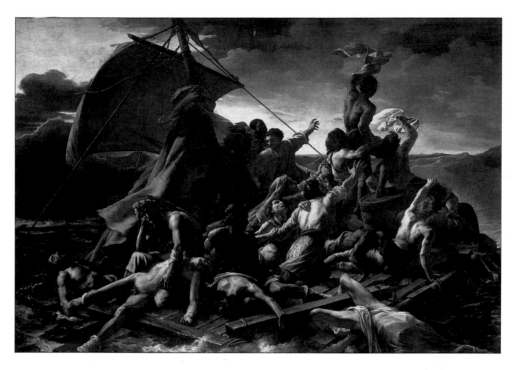

subject matter for paintings gradually shifted towards nature. The last historical subjects on a grand scale were made during the Neo-classical period (19th century) by painters such as Jacques Louis David (1748–1825) and Jean Auguste Dominique Ingres (1780–1867). These were artists who wanted to keep the spirit of the Renaissance alive and believed that the highest form of art was based upon the figurative image. Perhaps the last great classical painting that used heroic images of anatomically accurate construction was Théodore Géricault's (1791–1824) giant masterpiece *The Raft of the Medusa* [4.9 x 7.2m (16 x 23½ ft)], painted in 1819. Géricault took the quest for realism in anatomy one step further than ever before by making studies of recently executed victims of the guillotine. By the middle of the 19th century the study of anatomy survived as part of a typical art

The Raft of the Medusa
Théodore Géricault (1791–1824)

Considered one of the greatest depictions of the human form, this work shows the power of expression possible in representational art.

school education. The days when knowledge of anatomy was an intrinsic part of an artist's vocabulary were drawing to a close.

The growth of Modernism in the 20th century saw a revolution in working practices. No longer was it essential to understand the construction of the body. In fact, the appearance of people in a painting might not even be human. However, in the 21st century there are some major artists, such as Lucian Freud (born 1922) and David Hockney (born 1937), who are concerned with the human figure as a central theme.

MATERIALS AND EQUIPMENT

T his section introduces the wide range of materials and equipment that you can use to capture the human form. Each medium will help to enhance an aspect of your work.

The range of materials available is bewildering to say the least. Despite technological advances in many areas of life, artists' materials have remained, in essence, unchanged in their construction for centuries. There is a wider range of pigments available now and materials have been made easier to use. The way that we use these modern versions of traditional materials remains unchanged.

CHALKS

Red, black and white chalks are probably the oldest drawing materials in the world. They are found as natural rocks throughout the world. For the most part,

however, today we tend to use the modern stick form. This is more or less the same material, ground to a pigment, mixed with a setting agent and set into a mould to form a stick. A whole range of colours are available. Modern chalk can be sharpened to a point.

CHARCOAL

Made from various trees, charcoal is essentially charred wood. Some woods perform better than others – willow is the best and the most popular with artists. It comes in almost any thickness from wafer thin to very thick, depending on the size of the branches used. It is a

Above and below *Chalks and charcoal are some of the most ancient artists' mediums and are still popular today.*

beautiful material to draw with and has a delicate touch, capable of producing the gentlest of lines to the darkest, blackest tones. It can also be smudged or blended easily with tissue or a finger and has been a favourite drawing medium with artists for many centuries. Artists often use a fixative to prevent the final charcoal image from fading or being smudged.

PASTEL

This term is generally taken to mean soft pastels. As a medium, pastel is relatively modern, not being used much before the 18th century. Pastels are made from pigment bound together with a gum. When applied, the effect can be a dense area of pigment that resembles a painting in its opacity. Alternatively, it can be used in thin strokes, built up in layers known as cross-hatching. Pastel comes in an astonishing range of colours, gradated from the lightest tint through to the darkest. There are visually six to ten grades of each colour, depending on the manufacturer. Softness varies according to the manufacturer. Although the choice and range of pastels is huge, it is not necessary to buy an enormous selection. First-class work can be done with as few as a dozen colours. It is also possible to buy selection boxes that will pre-select a range of pastels according to subject — for instance, landscape or portrait.

FIXATIVE

If you choose to use any of the media mentioned so far, you may want to fix your work when it is finished to prevent it from smudging. Fixative can be applied from aerosol cans or with a blow-spray diffuser fed from a bottle. Any fixative, however good the quality, will to some extent take the edge off the sparkle of a pastel, so if you can store your work in a flat drawer where it will not be rubbed, so much the better.

PENCILS

The term 'lead pencil' is a left-over from the days when lead was used in artists' materials. Today we use graphite, which comes in grades, ranging from very hard to very soft. The grading begins with HB, which is in the middle, progressing to 8H (hardest) and 8B (softest). Generally speaking, artists tend to use the B range – the H range being more suited to technical drawing. Apart from graphite, there are many other forms of pencil, such as charcoal, chalk, pastel and wax crayons. Coloured pencils are now used extensively by artists, particularly in the field of illustration.

PEN AND INK

Once again, this is an ancient medium still in use today, with some modifications. Today we use mostly steel nibs, which come in all shapes and sizes and are fitted on to a penholder. These are known as dip pens. In addition, there are a huge

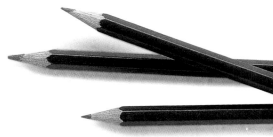

Pencils vary in consistency from soft (B) to hard (H). Artists tend to use the B range for the variety of shades that it can create.

number of commercial pens available that contain their own supply of ink. Traditional inks, such as sepia (made from cuttlefish) and iron gall ink (made from oak galls), were permanent and light fast. Many of the inks available today – either in bottle form or cartridge or as an integral part of a commercial pen – are impermanent.

Pastels are a relatively modern innovation. They require a set of techniques all of their own and can be difficult to master.

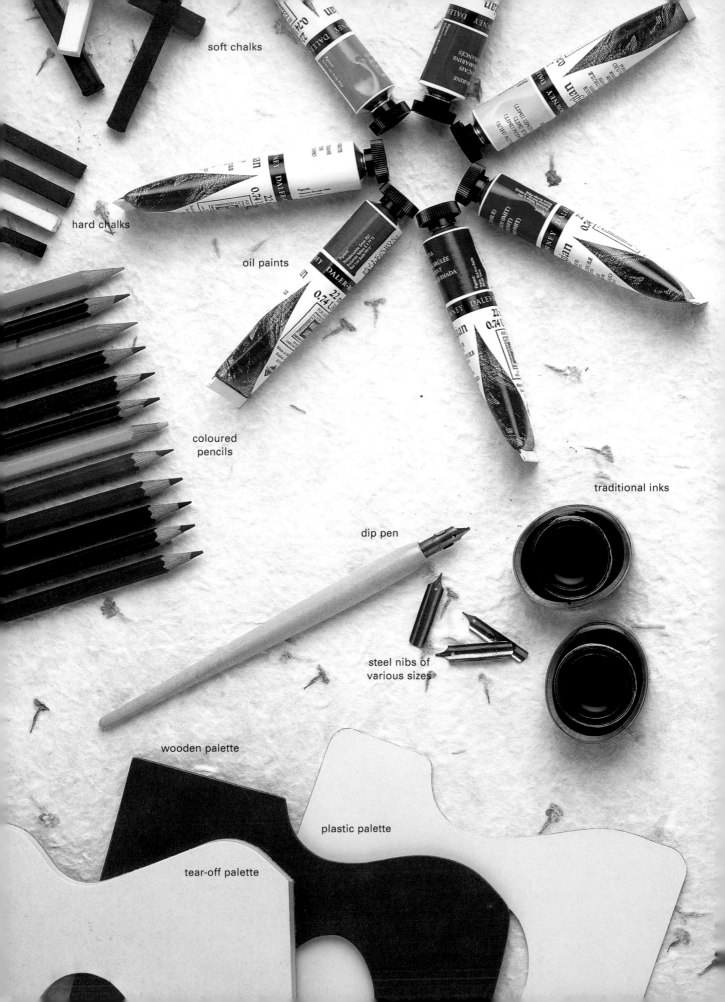

soft chalks

hard chalks

oil paints

coloured
pencils

traditional inks

dip pen

steel nibs of
various sizes

wooden palette

plastic palette

tear-off palette

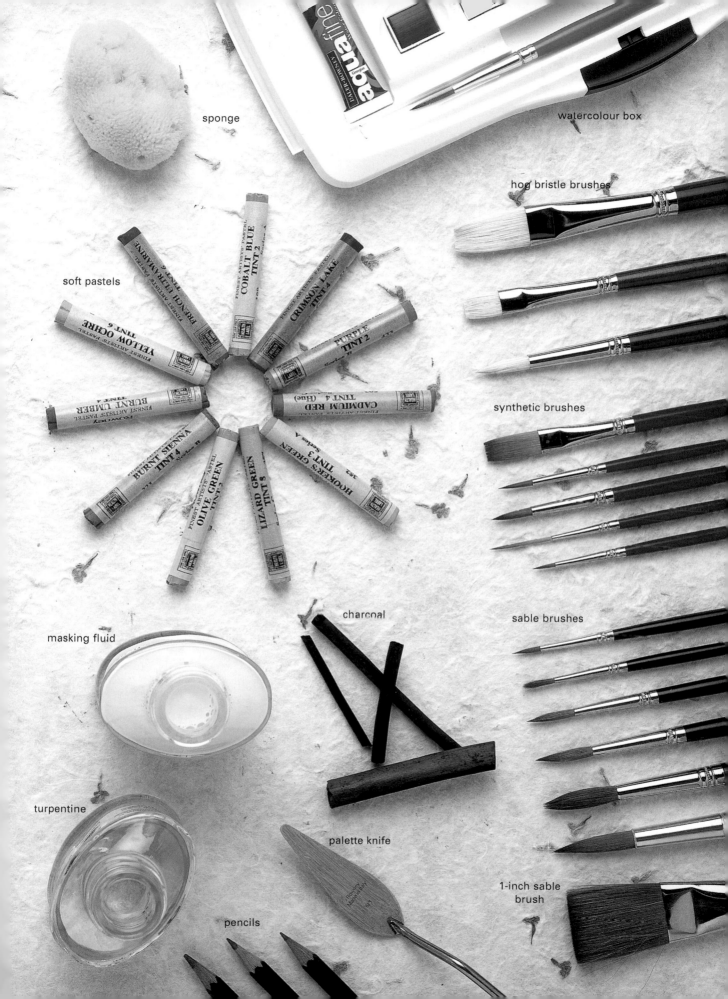

sponge

watercolour box

hog bristle brushes

soft pastels

COBALT BLUE TINT 2

FRENCH ULTRAMARINE TINT 6

CRIMSON LAKE TINT 4

YELLOW OCHRE TINT 6

PURPLE TINT 2

BURNT UMBER TINT 4

CADMIUM RED TINT 4 (Hue)

BURNT SIENNA TINT 4

HOOKER'S GREEN TINT 3

OLIVE GREEN TINT 2

LIZARD GREEN TINT 8

synthetic brushes

sable brushes

charcoal

masking fluid

turpentine

palette knife

1-inch sable brush

pencils

Another ancient medium, pen and ink, can be used in conjunction with media such as watercolour.

WATERCOLOUR

Watercolour paint is made by binding pigment with gum arabic. It is then put into tubes or left to dry and harden, after which it is cut into squares. The pan (cube) form is probably the most widely used. You can buy watercolour boxes either empty, or with a range of pans already selected. A pre-selected box is quite adequate until you gain some experience.

WATERCOLOUR BRUSHES

The best brushes for water-colour painting are sable. There are different grades, the top grade being very expensive. It is possible to get away with only one medium-sized brush, say a No. 9 or 10. The capacity to hold water and come to a point is essential. Ideally, a selection of round brushes comprising a No. 2, 5, 7 and 12 should cope with most demands. For much larger washes, a flat 1-inch brush might also be needed.

PAPER

For pencils, chalks and charcoal any standard, lightweight paper will work well enough. Paper with a tooth or grain is a good surface for chalk or charcoal. For pen and ink, a lightweight drawing paper without too much grain is most suitable. Commercially made pens will move on a surface texture much better than a dip pen, whose steel nib may get snagged and scratch the surface. If a wash is to be used, a heavier paper will be needed to avoid buckling.

There is a whole range of papers specially developed for pastel, and in a wide variety of colours. Because pastel is fully opaque, it works particularly well on a toned surface where both light and dark colours can be seen. Also, because it is dry there are no buckling problems, so lightweight papers can be used. However, surface texture is very important and will influence not just how the image looks but how much pastel can actually be applied before fixing becomes necessary.

The importance of paper to watercolour painting cannot be overstressed. The quality of any paper will have a profound effect on your painting. There are two basic types of paper: Hot Pressed, which has a smooth surface and is more suited to drawing than to water-colour; and Not – which simply means the paper is not hot pressed and so has a surface texture. The latter is the type of paper best used for watercolour, and ranges from light to heavy. There are also handmade papers that are beautiful to work on but also very expensive.

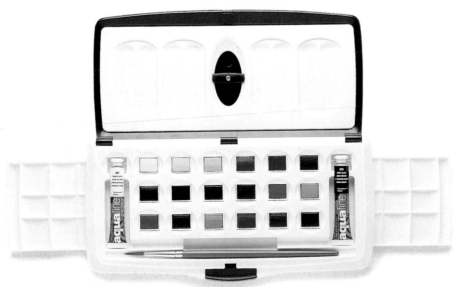

Watercolour is one of the most popular media among amateur artists. Portable watercolour sets such as this contain a range of pre-selected pan colours, with tubes of black and white pigment. As you gain in expertise you will be able to choose your own colours and create your own palette.

OIL PAINTING

Oil paint is made by binding pigment with a binding agent – usually linseed oil, although both poppy oil and walnut oil are used. Some sort of medium must be used to mix with the paint. This can be pure turpentine, although most painters prefer an addition of oil and varnish, which gives the paint a much fuller body. Drying times depend on the medium. Oil slows down the drying while varnish hastens it.

Oil paint should never be used straight on to paper, wood or canvas because the surface will be far too absorbent and also oil and turpentine will attack the unprepared surface. Traditionally, artists primed their own canvases or boards and even paper, which can work well – many of Constable's *plein air* oil sketches were made on paper and cardboard. These days it is much easier to go to the art supply shop and buy ready-prepared boards and canvases. If you become more involved with oil painting, then priming your own surfaces is great fun and, best of all, made to measure.

Oil paint is very flexible and can be used thinly to create a translucent effect or thickly for an opaque look. It is applied with bristle, sable or synthetic brushes or a palette knife.

Colours are mixed on a palette made of wood or plastic and large enough to allow them to combine freely. Tear-off paper palettes can also be used, but a good mahogany or hardwood palette becomes an old friend in a way that others do not.

Brushes should be cleaned in white spirit and then soap and water if you want them to last.

Cheap and easy surfaces to paint on can always be made by priming hardboard or MDF with acrylic primer.

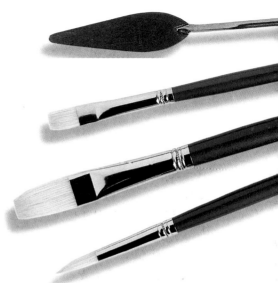

Above *There is an extensive range of brushes in various shapes, sizes and materials for oil paint. The palette knife is also popular.*

Below *Papers can vary in thickness, smoothness and colour. The selection of an appropriate paper can be a crucial factor to the final success of a work.*

HOW THE BODY WORKS

Aknowledge of how the body is structured and moves is essential for an artist who wishes to capture accurate depictions of human beings. This chapter provides a basic grounding in essential anatomy.

Although the study of anatomy can assist an artist in painting and drawing from life, it should never become a formula, and the portrayal of an individual should always take precedence. However well an artist might understand human anatomical construction, the way muscles appear on the surface is not always obvious – even in quite muscular people. This is due, in part, to a thin layer of fat called the panniculus adiposus, which is present in even the slenderest person or muscular super-fit athlete. Only in cases of extreme malnutrition and emaciation is this layer not present. Secondly, muscle development differs greatly between individuals, depending upon how they use their body. For instance, the muscle formation of boxers, runners, weightlifters and foot-ballers will all appear quite different on the surface.

Body builders of the type who go in for the 'Mr Universe' competitions are completely different once again. Here, a special programme is followed that deliberately targets specific muscles and consequently can enhance them beyond anything that natural activity or normal exercise can achieve.

We also have to consider the differences between the sexes. Broadly speaking, women have up to 30 per cent more fat than men, which can greatly affect how the muscles appear on the surface. Also, generally speaking,

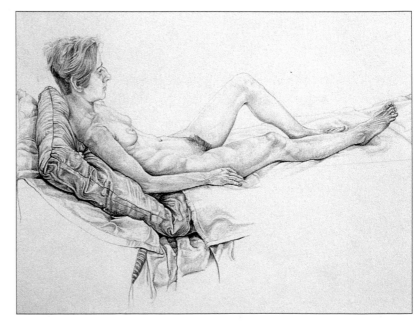

Although we all have the same basic building blocks, individuals differ superficially. To the artist, these differences define the individual.

The Skeleton

The human skeleton is a framework to which the muscles are attached. In all animals, the skeleton is directly related to the type of actions that the creature performs. This has been determined by millions of years of evolution and adaptation to the sorts of tasks that creatures needs to perform in order to survive.

The skeleton also has the important function of protecting vital organs. The skull, for instance, provides a hard, bony case to protect the brain. Likewise, the ribcage protects the lungs. For our purposes as artists, all we need to know about the skeleton is how it moves and which muscles attach to which bones.

Most bones are held together by muscles that are attached by tendons. It is the way in which these muscles link together various bones that defines our movements.

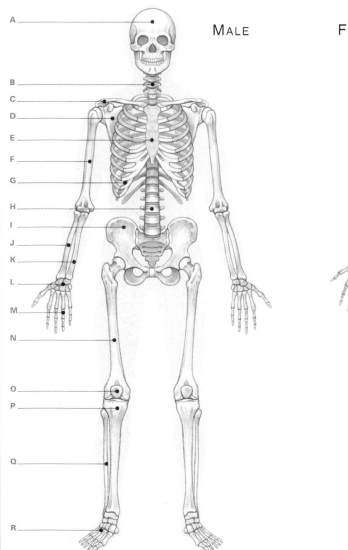

MALE

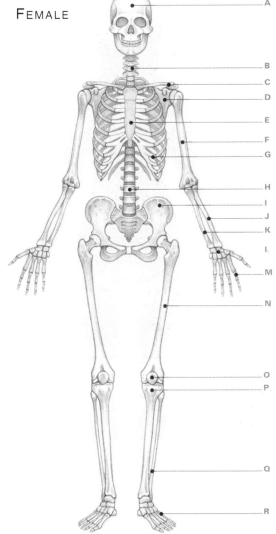

FEMALE

Above: A skull, **B** cervical vertebrae, **C** clavicle, **D** scapula, **E** sternum, **F** humerus, **G** rib cage, **H** lumbar vertebrae, **I** pelvis, **J** radius, **K** ulna, **L** carpal bones, **M** phalanxes, **N** femur, **O** patella, **P** tibia, **Q** fibula, **R** metatarsal bones

women tend not to perform as many manual tasks as men and therefore have less muscular development. However, in the modern world, where stereotypical role-play between the sexes is in decline, it is best to approach all situations with a very open mind.

As a figurative artist, to be able to work with knowledge of the structure of your subject is obviously an advantage and reduces the tendency towards copying or drawing in a way that ends up being over-literal. Understanding the construction of a subject, whether it is a boat or a human being, will always enhance your work.

THE HEAD AND NECK

The muscles of the head and neck can be seen to a large degree on the surface. It varies greatly between individuals,

but muscles such as the zygomaticus major, orbicularis of the mouth, masseter and buccinator, are all instrumental in creating facial expressions. Each of us uses our facial muscles quite differently, and will therefore have a bias towards some muscles being more developed than others. For instance, trumpeters have enormously developed buccinators because of all the blowing they do. People who smile a great deal usually have a prominent zygomaticus.

The most important neck muscle for artists is the sternocleidomastoid. This connects from behind the ear to the collar bone. It is the main anchor of the head to the shoulders via the neck, and can be seen on virtually anyone regardless of the degree of fat they have on their body. Also apparent in certain situations is the platysma.

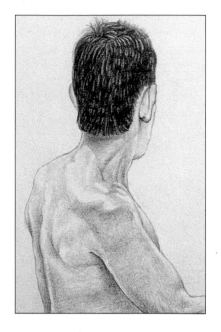

In this image the sternocleidomastoid muscle in the neck is clearly visible. This is one of the defining muscles for the artist.

This is a thin, sheet-like muscle of the neck. Wincing and expressions of terror make this muscle quite pronounced.

At the base of the neck is the trapezius muscle. This connects from the back of the skull to well down the spine. It also forms the principal muscle of the shoulder and has an overall shape similar to a diamond. Weightlifters and boxers can have extremely well-developed trapezius muscles.

The other important muscle of the shoulder is the deltoid. This is a powerful muscle and is

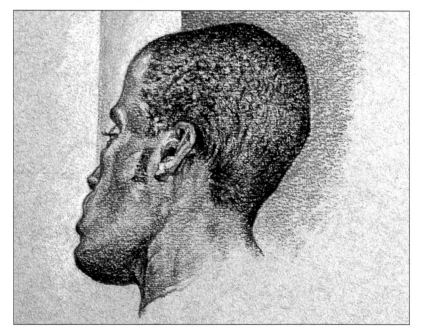

We all use our facial muscles in different ways. This can cause us to develop certain muscles while neglecting others.

The Muscles

In simple terms, all muscles connect from one bone to another so that when those muscles are tensed they can either pull those bones together or push them further apart. For every muscle movement there is another set of muscles to assist in doing the reverse. To make sense of the technical sounding Latin names, it is useful to understand the meaning of the following terms:

Abduction This describes the movement away from the body, e.g., lifting the arm upwards.
Adduction This is the opposite of the above: movement towards the central axis.
Extensor This is a muscle that contracts to straighten or extend a joint.
Flexor This is a muscle that contracts to bring together the two parts it connects.

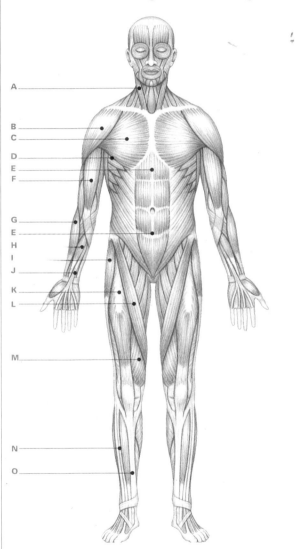

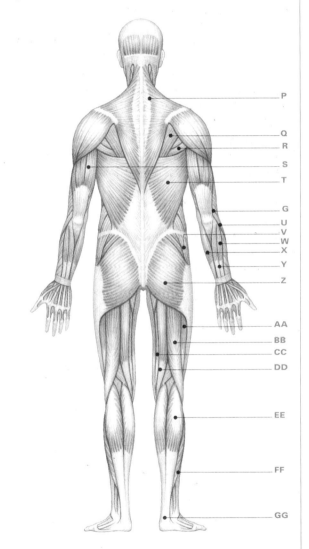

Above: A sternocleidomastoid, **B** deltoid, **C** pectoralis, **D** serratus anterior, **E** rectus abdominis, **F** biceps, **G** brachioradialis, **H** flexor carpi radialis, **I** tensor fascia latae, **J** palaris longus, **K** rectus femoris, **L** sartorius, **M** vastus medialis, **N** peroneus longus, **O** tibialis anterior, **P** trapezius, **Q** infraspinatus, **R** teres major, **S** triceps, **T** latissimus dorsi, **U** extensor carpi radialis longus, **V** gluteus medius, **W** extensor digitorum, **X** flexor carpi ulnaris, **Y** extensor carpi ulnaris, **Z** gluteus maximus, **AA** vastus lateralis, **BB** biceps femoris, **CC** semimembranosus, **DD** semitendinosus, **EE** gastrocnemius, **FF** soleus, **GG** tendon calcaneus

in constant use when the arm moves, as is the great abductor. In fact, most of the muscles of the arm are fairly easy to see on the surface. This is because even in the least sporty or active of individuals the arm is in fairly constant use and consequently the accumulation of surface fat is kept to a minimum.

THE UPPER ARM

As the name implies, the biceps has two heads and is the muscle that is usually associated with power and strength when flexed. The biceps are the flexor of the forearm.

The brachialis is a deep, powerful muscle that lies between the biceps and triceps and is a strong flexor of the elbow. It can usually be seen on the surface as a bump just below the deltoid on the outer side of the upper arm.

Occupying the whole of the back of the arm is the triceps, which, as its name implies, has

The inside of the forearm contains the finger flexors and the outside flexor for the forearm itself.

three heads. It is the principal extensor of the forearm and can easily be seen on the surface, especially when it strains, for example to lift a heavy object.

THE FOREARM

The muscles of the lower arm are numerous and complex in action. Unlike the upper arm, where the muscles are fewer but longer and perform actions of strength, the lower arm governs the movements of a much finer and more precise nature.

These muscles can be split into two groups: those that arise from the inner side of the

The armpit is formed principally by two muscles, the pectoralis major and the latissimus dorsi. When the arm is raised, these muscles are particularly visible.

humerus and those that arise from the outer side. Those that originate from the outer side are much higher than those arising from the inner, giving the forearm its characteristic curve. You will also notice that as the muscles become tendons at the wrist, the forearm is also slimmer than higher up nearer the elbow, where the fleshy ends originate. All of these tendons

connect to the phalanxes and metacarpals to perform a wide variety of dextrous movements.

THE TRUNK

The muscles of the trunk can also be divided into roughly two types: those that are long and thick, like the erector spinae group, and those that are broad and sheet-like in form, such as latissimus dorsi.

Along with the biceps, the other muscle associated with strength and fitness is a well-defined rectus abdominis. The rectus abdominis is a long, flat muscle extending the whole length of the abdomen. It begins at the pubic crest and inserts into the cartilage of the fifth, sixth and seventh ribs. This muscle is responsible for bending the trunk forwards and is used in sit-up exercises.

At the back, the erector spinae muscles extend the whole length of the spine and fill the groove either side of the spinal column. These muscles connect from the pelvis and sacrum all the way up to the cervical vertebrae. Although not truly superficial, these muscles are important to the artist because their effect can always be seen in the form of a furrow down the centre of the back.

At the top section of the thorax, the erector spinae is covered by the trapezius and below by the latissimus dorsi. The latissimus dorsi muscle is the wide muscle of the back and at its outer edges it forms a thick ridge that can be seen to great effect in many athletes.

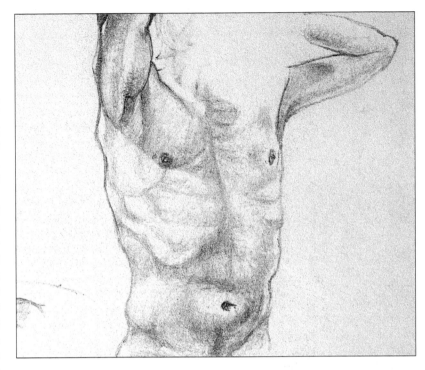

At the front, on the chest lies the pectoral muscle. With the latissimus dorsi, this forms the armpit over either side of the ribcage. On muscular males, the pectoral can achieve very good definition because of the part it plays in moving the arm. Boxers and weightlifters can often develop this muscle so much that the individual fibre strands can be seen. On the female, however, this muscle supports two-thirds of the mammary gland (in the breast) so it figures far less, although it is always evident as an important part of the armpit form.

Beneath the armpit and directly between pectorals and latissimus dorsi is the serratus anterior, otherwise known as the fencer's muscle. The bumps that appear on the surface are

The front of the body is defined by the ribcage, the pectoral muscles and the rectus abdominis, which runs from the chest to the pelvis.

often mistaken for ribs in thin people but when this muscle is developed, as it is in boxers, who are constantly performing lunging movements, there is no mistaking it for the ribcage.

Because of the way the serratus anterior attaches to the ribcage, it produces an interlacing effect with the external oblique. This is a large sheet-like muscle that attaches to the top of the iliac crest of the pelvis and is easily seen on the surface in most males. It is generally less visible in females, however, because at this point on the hips there is usually a greater fatty covering than on males.

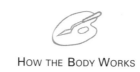

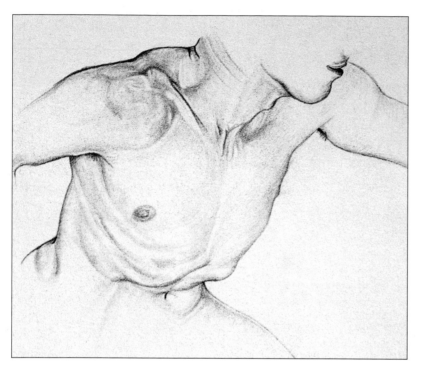

At the shoulders and upper back, the deltoid and trapezius muscles are most prominent.

To return briefly to the back, it will be noticed that there is a large area in the centre that is formed by a tendon common to several muscles. This gives great strength to this part of the body, and in muscular individuals it is possible to identify separate muscle movements.

THE UPPER LEG

The buttocks and legs contain some of the longest and most powerful muscles of the body, many of which can be seen superficially. The heaviest and strongest muscle in the body is the gluteus maximus, which is the main muscle of the buttock. It is the large extensor of the thigh and is used for rising from a sitting position and leaping, etc. It is usually a larger muscle in the male although, because of the extra accumulation of fat, the superficial appearance of the female buttock is larger than that of the male.

The gluteus medius muscle is a fan-shaped structure that is a strong abductor of the thigh and is used in such actions as standing to attention. The other important muscle in this region is the tensor fascia latae, which joins a long area of tendon known as fascia latae or the ilio tibial band. The tensor fascia latae runs the whole length of the upper leg, tapering at the end to join at the fibula.

The other muscles of the thigh are the rectus femoris, the inner vastus and outer vastus.

These muscles run the whole length of the femur bone arising from the pelvic area and join in a mass of tendon at the patella, or kneecap. Together with the other muscles, the rectus femoris serves to straighten the knee and flex the thigh.

Between the femur, pelvis and innermost part of the upper leg is a triangular shape filled by a group of muscles known as the adductors. The adductors longus, magnus and brevis together with pectineus perform the same function, which is adducting the thigh. They would be used, for example, when riding a horse to keep the thighs pressed tightly against the saddle and for bringing the leg, which has been lifted away

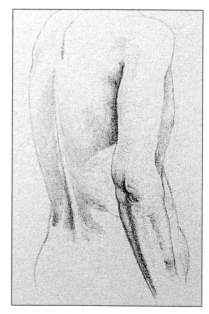

The main feature of the back is the furrow surrounding the spine. This is created by the erector spinae muscles.

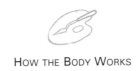
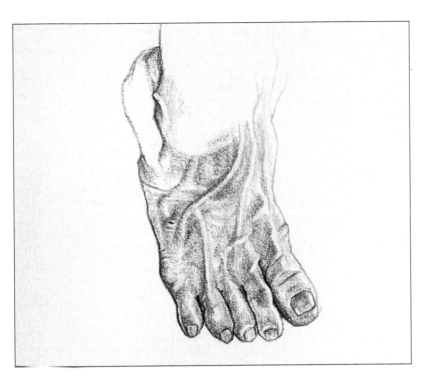

The foot muscles are thin and look like tendons on the surface.

from the body, back again. At the back of the leg, the principal muscles are the biceps femoris, semitendinosus and semimembranosus. These long muscles are the flexors of the knee. When the knee is in a bent position the tendons of these muscles stand out like taut strings. This appearance has earned them the name of hamstrings.

Joining at the same point at the inner side of the knee on the tibia bone are the two last muscles of the upper leg – the sartorius and gracilis. A knowledge of the sartorius muscle is important to artists, because it defines the whole character of the upper leg, as it effectively bisects the whole area.

THE LOWER LEG

There are not very deep muscles in this part of the leg, as the area is mostly occupied by the somewhat sturdy shin bone. At the front, the most easily seen and powerful muscle is the tibialis anterior, which raises the foot towards the leg.

There are two outer muscles in the lower leg, peroneus longus and brevis, which can be seen quite well when performing their function of pointing the sole of the foot outwards.

At the back, in the area known as the calf, there are two muscles, the soleus and gastrocnemius. The soleus is the deeper of the two and runs right underneath the two halves of the gastrocnemius. It can be seen on the inner and outer side of the leg. The two heads of the gastroc-

nemius can be seen when it is performing its main job, which is standing on tip-toe. Both these muscles unite at the lower end in the tendon to form the Achilles tendon and attach to the heel bone.

THE FOOT

The muscles of the foot are not very fleshy. They are seen on the surface as tendons that originate from the muscles of the leg as they attach to the phalanxes.

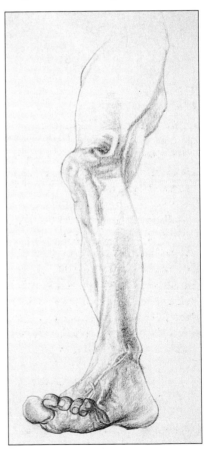

The lower leg is defined by the tibialis anterior at the front and the two heads of the gastrocnemius and their tendons to the rear.

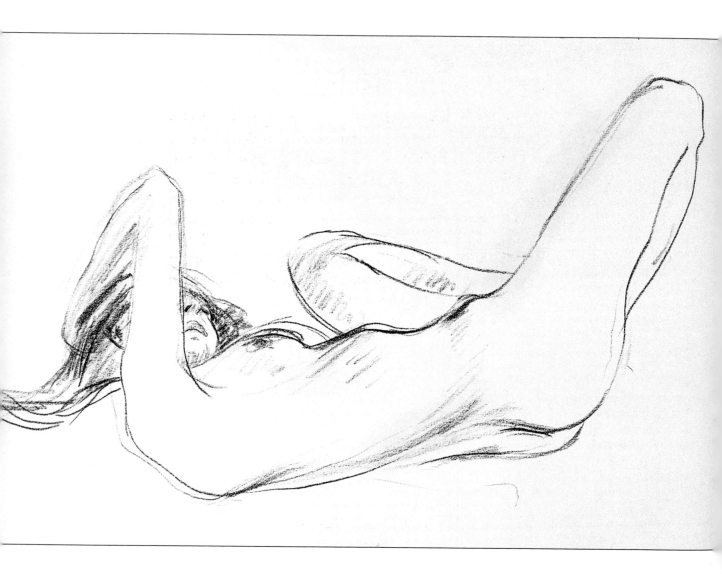

GALLERY

The works shown here demonstrate the degree to which a knowledge of anatomy affects accurate depictions of the human body. From the general proportions of the body to its surface details, anatomical considerations are crucial when drawing or painting the human figure – whatever style you use. The range of styles used here demonstrates that the same knowledge of anatomy does not mean that pictures will end up looking the same. This standard knowledge gives artists the freedom to use their individual styles while still achieving a high degree of anatomical accuracy.

Reclining Nude
Kay Gallwey
30 x 40cm (12 x 16in)

In this stunningly energetic drawing of a reclining woman, the artist has responded to the femininity of the model through the expressive use of line. The hips and raised leg in particular contain a highly sensuous use of linear definition.

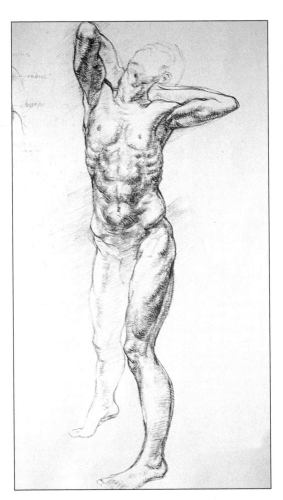

Anatomical Study

James Horton
30 x 20cm (12 x 8in)

This drawing was a deliberate attempt to make an anatomical study. The model was chosen for his well-developed body. The work was a wonderful opportunity to utilize previous knowledge of the geography of the human body in a drawing.

Weights

John Holder
30 x 40cm (12 x 16in)

This drawing demonstrates the relation of biceps and triceps to the lower arm. The tension can be seen quite clearly in the form of parallel bulges running along the arm.

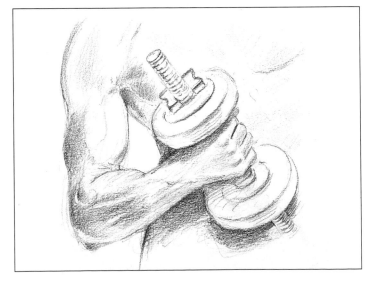

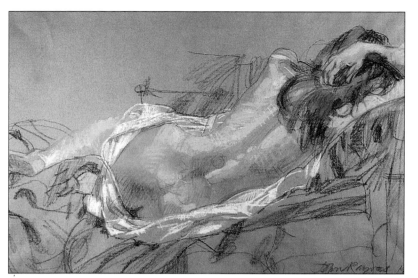

Geraldine
John Raynes
18 x 25cm (7 x 10in)

In this fresh-looking image the artist manages to achieve a balance between free-flowing chalk marks and accurate anatomical representation. This freedom comes with an in-depth knowledge of anatomy, which allows the artist to focus on his art.

Long Thin Man
Paul Bartlett
25 x 17.5cm (10 x 7in)

In this finely detailed, textured drawing in graphite pencil, the artist emphasizes the contours of the body with gentle shading. The bones and surface muscles are prominent in this study, especially on the back. The shoulder blades, spine, erector spinae and latissimus dorsi can all be seen very clearly, while the legs are shrouded in heavy shadow. The fine detail suggests a comprehensive knowledge of anatomy.

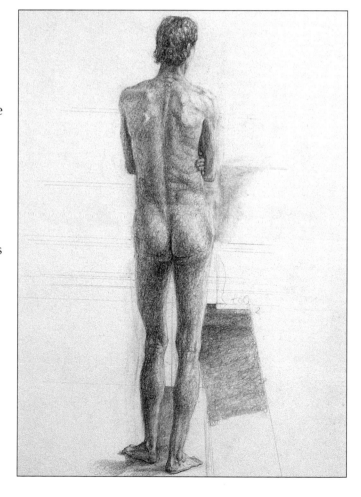

Lynton (seated)

Paul Bartlett
35 x 22cm (14 x 9in)

In this charcoal study the development of the form has been taken up to quite a high and 'polished' looking level. The superficial anatomy works well and there are many familiar anatomical landmarks – particularly in the construction of the shoulders, chest and thorax.

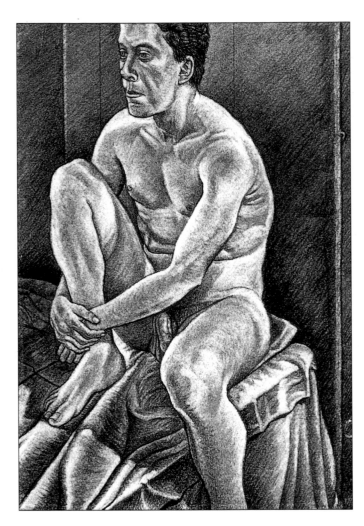

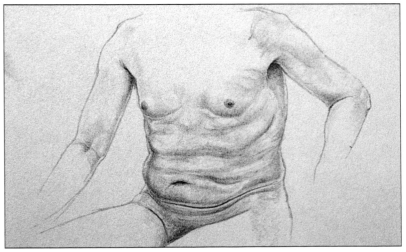

Chest and Arms (seated)

Paul Bartlett
27 x 18cm (11 x 7in)

In this drawing, the folds of the skin on the chest and stomach are accentuated through light pencil strokes and gentle shading. The shape of the pectoralis muscles, ribs and serratus anterior are suggested beneath the surface.

GALLERY

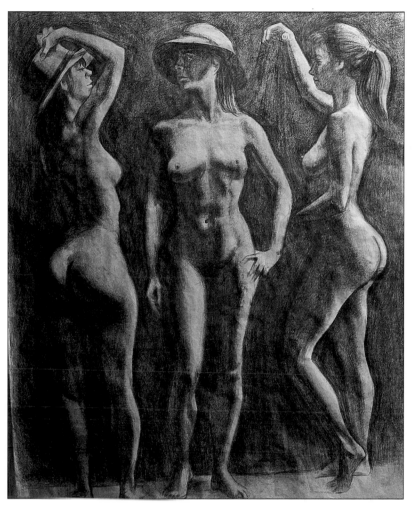

The Three Graces

James Horton
150 x 90cm (60 x 36in)

In this drawing the same model has been used three times. The central figure has excellent definition through the torso. The other figures display the deep curve in the spine typical of the female figure.

Anatomical Study

Byron Howard
28 x 18cm (11 x 7in)

In this pencil sketch the artist shows a detailed knowledge of the anatomy of the male back muscles, which are exposed on the left side. By contrast, the muscle structure provides a framework for the right side of the back, which focuses on the latissimus dorsi.

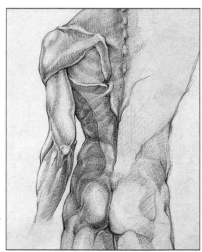

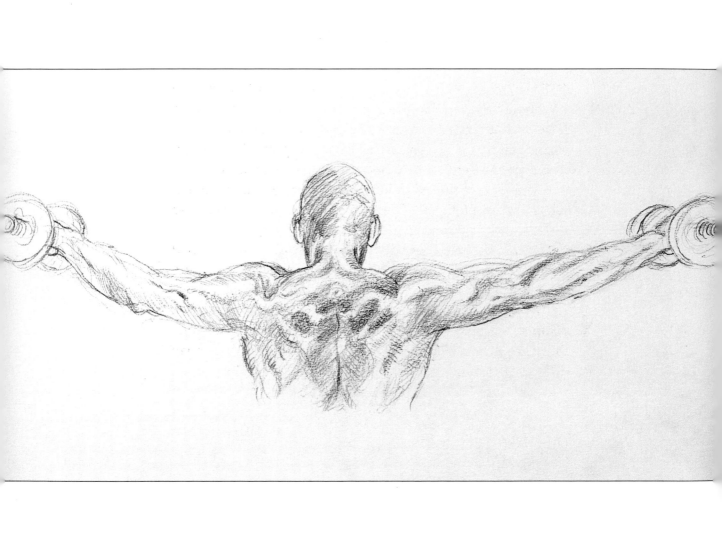

Project

1

ARMS

The arms are often central to a work of art containing human figures. They are highly expressive in their own right and can be used to convey the mood, intention or inner state of a figure. They can also be used to express abstract subjects such as strength, weakness, anger, passion and so on.

In this project the artist, John Holder, has chosen a pose in which many of the muscles of the arms are visible. Also visible are the muscles of the shoulder, neck and upper back – all of which interact with the arms. John has used pencil for this study, demonstrating how accurate figure drawing can be achieved with a basic two-tone effect.

This project emphasizes how the limbs work using a complex system of muscles and tendons. It also shows how the state of tension and the position of the limb make a huge difference to its general appearance.

John Holder
Weights Study
29 x 42cm (11½ x 17in)
Graphite Pencil

Arms Tensed

The muscle that is enabling the subject to raise his arms is the deltoid, which is the main elevator of the humerus. However, to raise the arm above the horizontal requires the added cooperation of other muscles, namely the serratus anterior under the arms and the trapezius between the arms in the back. The latter can be seen quite well defined in this subject.

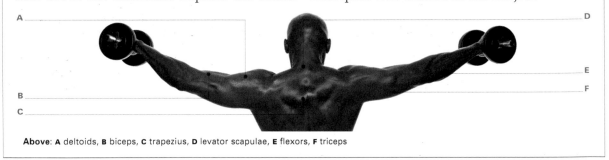

Above: A deltoids, **B** biceps, **C** trapezius, **D** levator scapulae, **E** flexors, **F** triceps

WEIGHTS STUDY

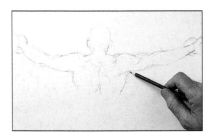

1.

Using a graphite pencil, roughly sketch the general proportions and shapes of the figure, using light strokes from the side of the pencil. To create a freer feel to the marks, hold the pencil further up so that it sits more lightly in the hand.

Materials and Equipment

• PHOTOGRAPH OF

OUTSTRETCHED ARMS

• GRAPHITE PENCIL 4B •

SKETCH BOOK • ERASER

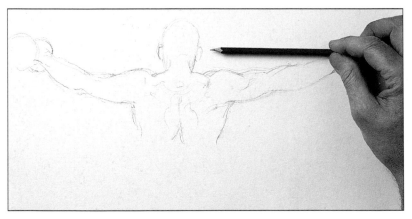

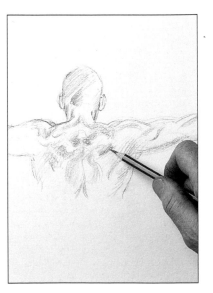

2.

Use your pencil to approximately measure the horizontals – both arms should be of equal length and proportion. The head of the figure and the weights should be more loosely drawn, in order to give greater emphasis to the arms and back. The weights should only be outlined, without shading.

3.

Before proceeding further, check the proportions of the figure. Use heavier strokes to strengthen the outlines and make the figure more clearly defined. Bring to life the features of the back, arms and shoulders with light shading using the side of the pencil.

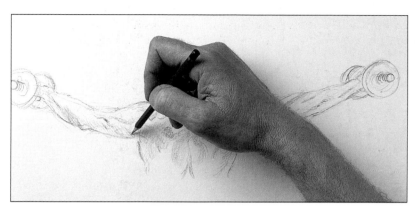

4.

The lines of the arms should not be be straight and should be loosely drawn: a series of connecting lines rather than a single line will give more fluidity. Single lines along the bottom of the left arm create the appearance of downward movement.

5.

Flowing lines along the right arm create a horizontal movement that emphasizes the outstretched pose. Build up the form using the side of the pencil. Increase the shading in areas of the arms to highlight the muscle tone. Darkening will emphasize the light areas and give greater depth and tone.

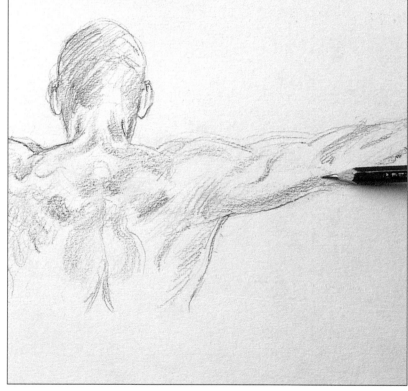

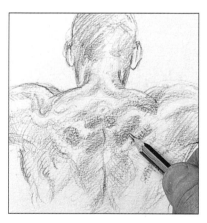

6.

Increase the shading on the back so that the white areas establish the highlights of the well-sculptured muscles. Use the pencil like a brush, stroking the side along the paper. Increase the weight to increase the colour and contrast. Soften some of the shading with your finger to give a more natural look.

7.

Use an eraser to pick out occasional highlights on the knuckles and back. Follow the curve of the muscles with your pencil to give the image a more fluid look. To finish off, darken the overall outline of the drawing to provide greater definition.

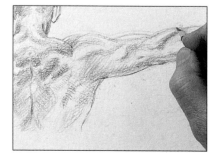

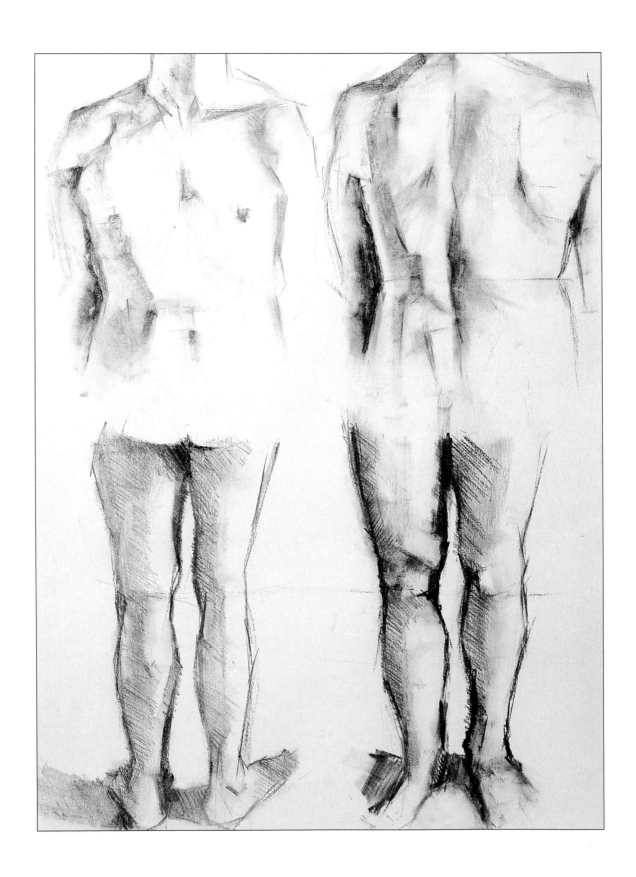

TORSO AND LEGS

In this project, the figure is standing, but there is no specific tension or stretching taking place. Therefore the muscles are relaxed and the lines of the figure gentle. The side lighting helps to accentuate surface details of the figure.

One of the key elements to get right in this project is the proportions of the limbs and the torso. The human body is basically a symmetrical object, so make sure that each side of the torso and the two legs mirror each other.

Barry Freeman
Male Study
75 x 56cm (29½ x 22in)
Charcoal

Drawing Torso and Legs

On either side of the sternum are the pectoral muscles, which can cause quite a furrow. Attaching the ribcage to the pelvis is the long and powerful rectus abdominis, well defined in this picture and also known as the 'six pack'. The external oblique always appears as a slight bump just above the iliac crest of the pelvis.

The whole character of the centre of the back is defined by the furrow caused by the erector spinae group of muscles. These attach along the whole length of the spine from the cervical vertebrae to the pelvis. At the top the trapezius lessens the furrow effect as it swathes the erector spinae along with the other numerous muscles of the shoulder and neck region.

The upper leg contains the most powerful muscles in the body. These are all long and thick, with the exception of the vastus lateralis, which is narrower. At the front the diagonal quality of the sartorius is always noticeable.

The contour of the lower leg is defined almost entirely by the gastrocnemius muscle, which has two halves, the inner and outer. These connect with the soleus at the lower end.

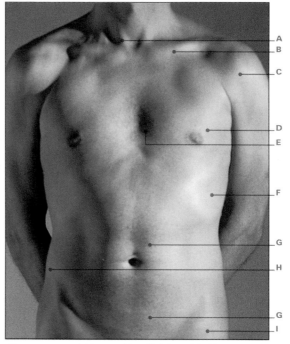

Above: A sternocleidomastoid, **B** clavicle, **C** deltoid, **D** pectoralis major, **E** sternum, **F** serratus anterior, **G** rectus abdominis, **H** external oblique, **I** tensor fascia latae

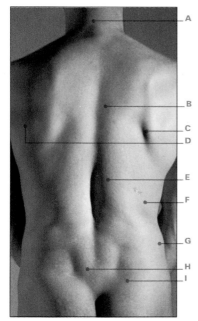

Above: A 7th cervical vertebrae, **B** trapezius, **C** scapula, **D** teres major, **E** erector spinae, **F** lattisimus dorsi, **G** external oblique, **H** aponeurosis of lattisimus dorsi, **I** gluteus medius

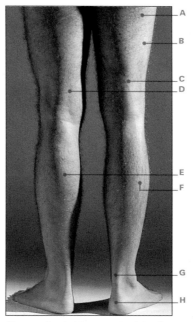

Above: A fascia latae, **B** vastus lateralis, **C** biceps femoris, **D** tendon of semimembranosus, semitendinosus and sartorius, **E** gastrocnemius, **F** soleus, **G** tendon calcaneus, **H** calcaneus

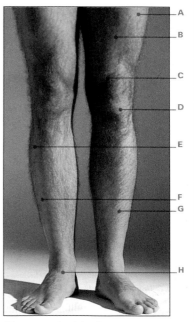

Above: A vastus lateralis, **B** rectus femoris, **C** vastus medialis, **D** patella, **E** gastrocnemius, **F** peroneus longus, **G** tibialis anterior, **H** extensor digitorum longus

MALE STUDY

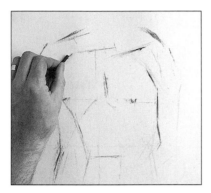

1.

Lightly sketch in the most obvious shapes and lines of the model. At this stage, concentrate on the proportions, marking the nipples, navel and the tops of the shoulders. These are your anchor marks.

Materials and Equipment

• CHARCOAL STICK • MEDIUM
CARTRIDGE PAPER
• ERASER • FIXATIVE SPRAY

2.

Use the point of the charcoal to strengthen the outline and build up shadow on the arm. This will highlight the torso. Criss-cross the chest with charcoal and blend it in with your finger to give soft shadow.

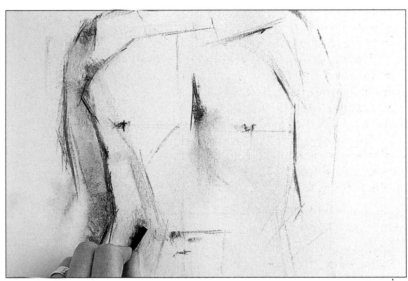

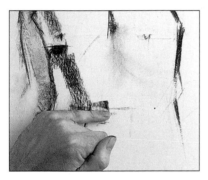

3.

Check which muscles are most evident. Use bold, confident strokes and vary between the edge and point of the charcoal. Make one thick long stroke following the shape of the muscle down to the abdomen and smudge it in with your finger.

4.

Use light strokes on the right, where there is less definition and shadow. Blend the left side, especially around the neck and the upper shoulder.

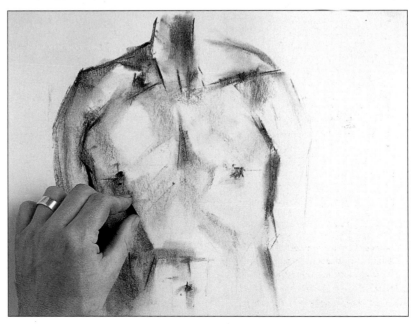

5.

Increase shading on the arm, then blend in the charcoal. Add some very precise lines down the side of the body. Strong dark lines on one side of the body and lightness on the other shows how the light is falling on the torso. Draw light lines to show the ribs, then add shading in between. Rework the abdominal area to bring out more definition.

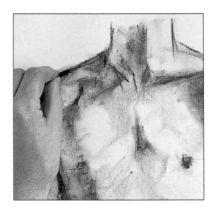

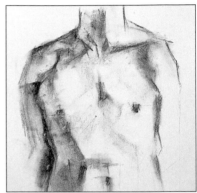

6.

Deepen the centre line of the sternum between the pectorals. Suggest the nipples and belly button with shading rather than specific detail.

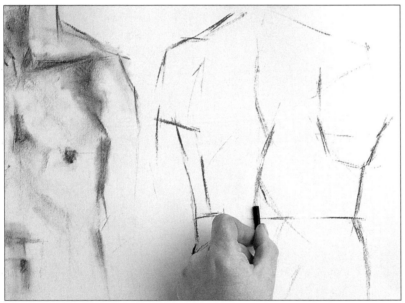

7.

Now move on to the study of the back. Using the previous picture as a guide for proportions, use a long piece of charcoal and lightly sketch in the basic shape – shoulders, spine, arms and shoulder blades.

8.

Use the side of the charcoal to block in the top of the shoulder and shade down the side of the body. Using bold strokes, draw in thick lines to show the main shadows on the back.

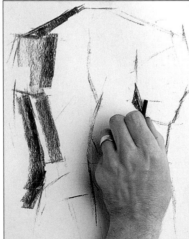

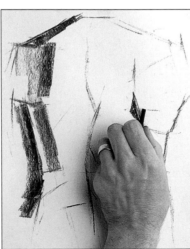

9.

Shade in around the spine. Protect the drawing with a sheet of paper if you need to lean on it – otherwise it will smudge. Blend in the strong lines at the tops of the shoulders to shape the curve.

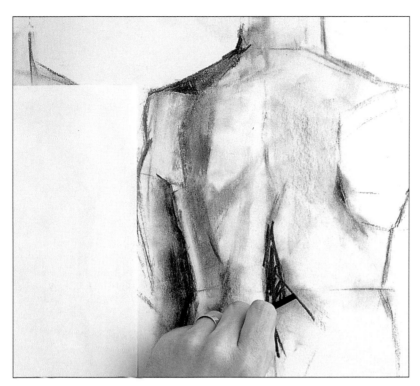

10.

Build in light shades, alternating between short and longer charcoal as appropriate, and leaving the lightest areas as clean paper to show highlights. Notice the soft texture on the back where there are fewer muscles and there is less definition. Shade in the dark shadows of the arms with very dark lines. Draw even darker lines to show the central spine.

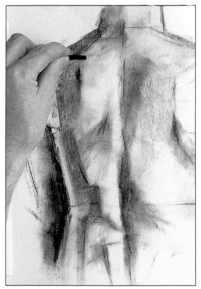

11.

Build up shapes and shadows. Notice the definition between the shoulder blades and the softening of the flesh around it.

12.

Check the whole image for areas that could be defined more clearly. Be sure to leave lots of white space for the highlight areas.

13.

Now draw the backs of the legs. Measure the proportions carefully. Draw a light guideline across to help with the proportions, plus a line down the centre of the calf. After you've sketched one leg, extend the guideline across and sketch in the second leg, using the scale of the first leg to help you. Using the side edge of the charcoal, strengthen lines once the shape is basically correct. Notice the squarish shape of the feet and prominent ankle bone.

14.

Block in the shaded area with the thick side of the charcoal. Use very dark shading on the inner legs, lighter on the outer legs. There is also dark shading on the inner ankles and on the floor between the feet to give the picture a base. Now sketch in lines around the foot and give the toes some darker shading.

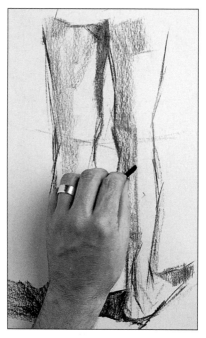

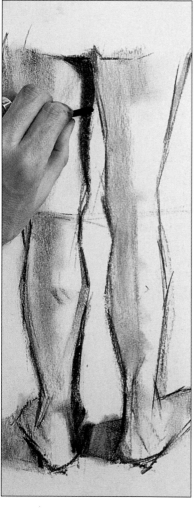

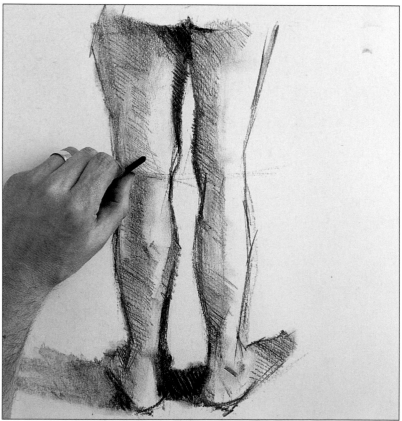

15.

Gently blend in the shading to bring the picture to life. Leave areas of paper white for the highlights. Sketch in the inner edge of the left leg. Notice how the shadow creates the edge. Notice also the angular shape of the ankle bone.

16.

Add final details and build up layers of shadow, using the side of the charcoal to create the dark shading.

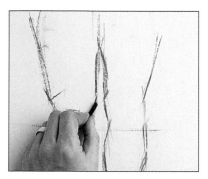

17.

Now draw the front of the legs. Draw a light line across the knees, strengthening it once you feel sure of the proportions.

18.

Now start to sketch in the shadows, using strong lines to show the dark areas between the legs. Draw strong lines around the knee to show the muscle. Use smooth, long strokes to sketch in the lighter areas of shadow. Block in the shadows on the feet to anchor the picture.

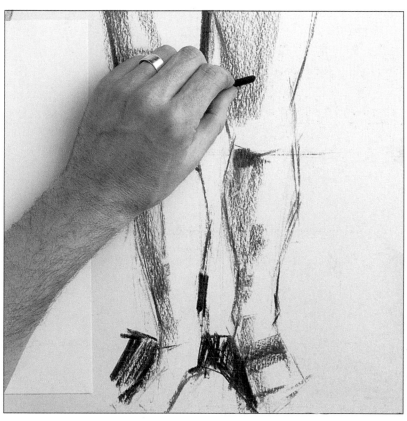

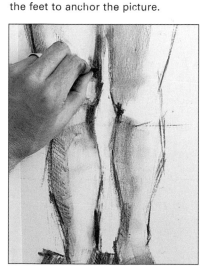

19.

Gently blend in the shading. Vary the direction of the blending so that it doesn't look uniform. Leave clear areas of white for highlights.

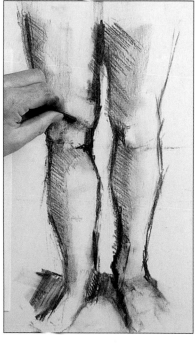

20.

Add the linear shading, following the shape of the shadows. Apply dark shading between the legs. Draw in the shadow around the feet to create a suggestion of weight. Add a few sharper lines across the knee, then blend them in. Finally, spray the picture with fixative.

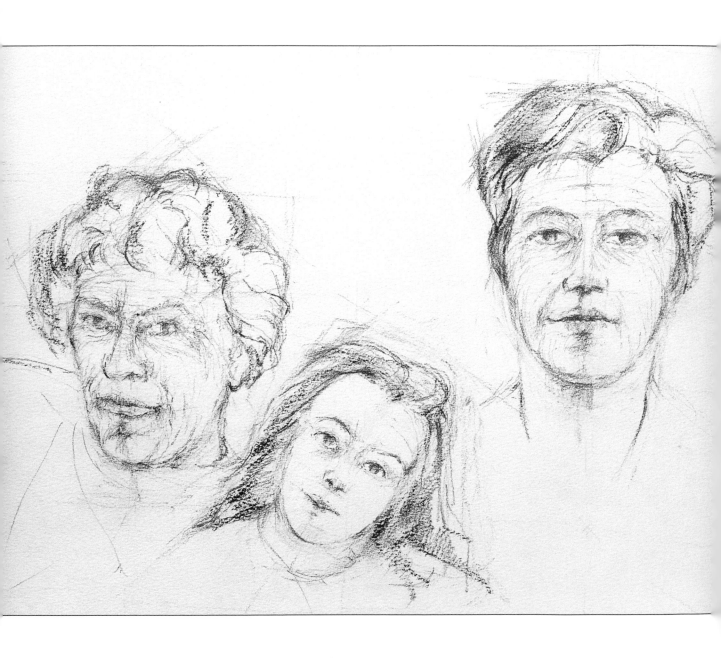

Project

3

HEADS

This project takes three generations of the same family as its subject. The use of a single colour heightens the comparative effect of the work. The fact that the subjects are all part of the same family allows the artist to focus on the changes caused by the ageing process. These include deep anatomical changes as well as the more obvious surface ones. A knowledge of the anatomical changes that take place over the years of a person's life enables an artist to know what to expect and therefore to capture the features that convey age. A comparative study serves to highlight these features.

Charmian Edgerton
Three Generations
30 x 40cm (12 x 16in)
Red Chalk

Anatomy and Age

The ageing process dramatically affects the outer appearance of the human body. It starts to be noticeable in middle age, causing a number of physiological changes. However, of most relevance to the artist are the weakening of the muscles and loss of elasticity in the skin. This causes features such as the skin to wrinkle and the skin under the eyes to sag.

There are also other changes that occur to the human body with age. In comparing the three heads in this project we notice not only the changes in the outer appearance of the face, but also changes in the shape of the skull itself. When we are born, our skulls are much larger in proportion to the rest of our bodies than when we reach adulthood. This is due to the fact that our brains grow faster than our bodies at this early stage. Human beings are unique in the animal world for the amount of development of the brain and the skull that occurs after birth. A newborn baby has large areas of soft cartilage in place of bone in the calvaria (the domelike part of the skull). As we grow, bone develops over these areas. We start life with bulges on either side of the forehead (the frontal eminences) and on both sides of the calvaria (the parietal eminences). However, the facial areas are much smaller in proportion to the skull as whole. This ratio is what gives babies and children their distinctive features.

THREE GENERATIONS

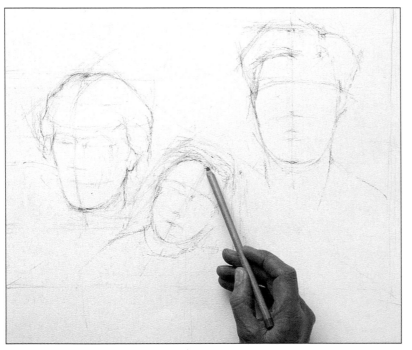

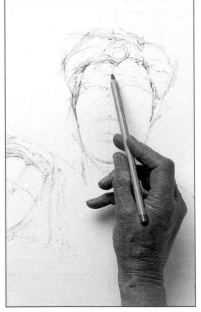

1.

First, mark out your paper. Draw a light rectangle, divided down the middle and then cross it off into 16 squares. Make some marker points for the top and bottom of the heads and then draw in some basic egg shapes. Outline the hair and mark in the positions of the facial features.

2.▸

Look at how the light defines the nose, the brow, the chin, etc. Draw in the basic forms, thinking about the underlying bone structure. Don't draw in the eyes at this stage.

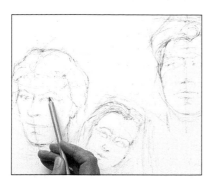

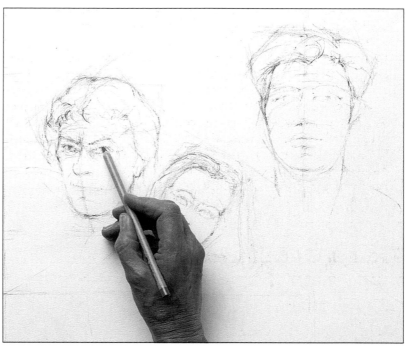

3.

Mark in the dominant eyebrows of the grandmother. Also emphasize the top of the cheekbones.

4.

Mark in the grandmother's eyes. Now move on to the child. Her features are softer and less defined, so use gentler touches.

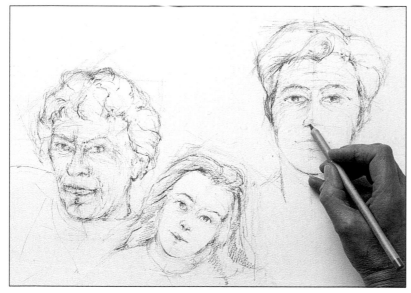

5.

The mother's features have become defined by age, but the flesh has not receded as the grandmother's has. There are more lines to draw than on the child's face, so sketch these in gently first before defining them.

6.

Now that all the basic forms are in place, go over each face defining the detail. The child's face should be fairly free of marks, the mother's slightly more detailed and the grandmother's the most interesting. Pay particular attention to the eyes of the mother and grandmother. Age makes the eyes particularly expressive, as the muscles weaken and the surface flesh droops.

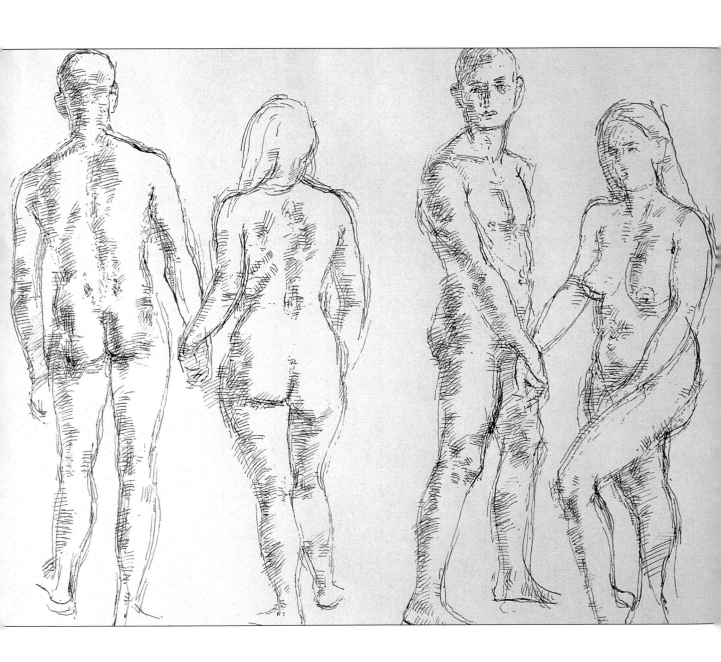

Project

4

MALE AND FEMALE

This pen and ink project focuses on the visible anatomical differences between the male and female form from both the front and rear views. Although the figures are heavily cast in shadow, light and tone should not be emphasized in this composition, as they are likely to distract attention from the differences in form and anatomy. Both views subtly stress this difference: the man stands straight and static in both photographs, while the woman takes a more active pose, as well as reaching out towards the man to hold his hand.

James Horton
Comparative Study
32 x 48cm (13 x 19in)
Brown Ink

Comparing Male and Female

In this picture we see the most typical differences in superficial anatomy between the sexes. In addition to the height difference between the two figures the most noticeable differences in the overall body shape are the shoulder to hip ratio and length of back to legs ratio.

Notice the steeper angle of the trapezius in the male, as this is generally a more powerful and well-developed muscle. Also the muscles of the hips and pelvis are much more tightly defined compared to the larger equivalent on the female. In these two subjects the gluteus muscles would be much larger in the male, but superficially the female's buttocks are much larger due to the accumulation of fat. It is interesting to note that the contours of the legs are very similar, due to the minimal amount of fat. In this standing pose the muscles are relaxed and there are no specific regions of stress. The spine and pelvis are the principal supporting structures in this position, and the line formed by the erector spinae dominates the back.

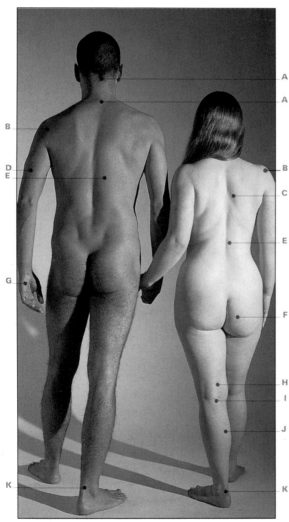

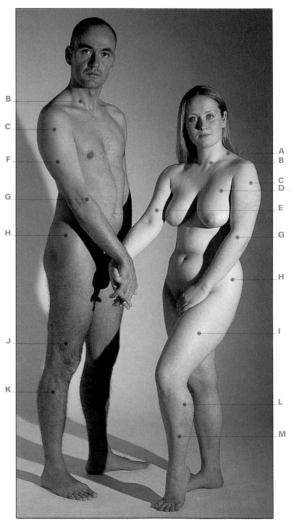

Above: A trapezius, **B** deltoid, **C** scapula, **D** triceps brachii, **E** erector spinae, **F** gluteus maximus, **G** ulna, **H** biceps femoris, **I** common tendon of sartorius, gracilis, semimembranosus and semitendinosus, **J** gastrocnemius, **K** tendon calcaneus

Above: A trapezius, **B** sternocleidomastoid, **C** deltoid, **D** pectoralis major, **E** biceps brachii, **F** brachialis, **G** extensor carpi radialis longus, **H** gluteus medius, **I** vastus lateralis, **J** biceps femoris, **K** peroneus longus, **L** gastrocnemius (outer head), **M** tibialis anterior

COMPARATIVE STUDY

1.

Using an old-fashioned drawing nib and brown ink, sketch out the tallest figure first. You need to outline the tallest figure before looking at the relationship between them. The linking place should be sketched first. This provides a central reference point for the whole composition. Sketch in the outline and muscle tone at the same time, beginning with light strokes.

2.

Once you have lightly outlined the proportions of the man, work out the proportions of the female. Note the angles of the bodies and plot key landmarks: the curvature of the spine and buttocks, the position of the legs. The woman should have less muscle construction and more fat: do not be tempted to add too much definition to her shape, or you will lose this softness.

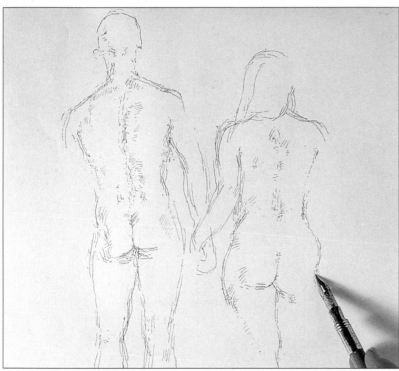

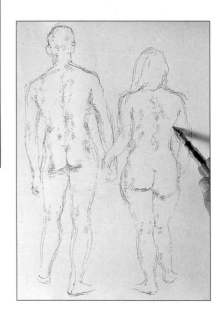

3.

Strengthen the shape of the composition by re-evaluating the relationships between the different parts of each body and between the two figures. Tracing down the backs and legs will emphasize the natural curve of each body.

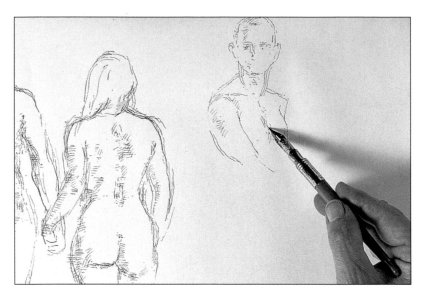

4.
Use the first illustration as a reference point when beginning the front view. Avoid starting too low down, as the two sets of figures need to be in proportion to each other. Start with the tallest figure, sketching out the form lightly, and then building up a series of layers. The facial features are important for the front view: begin by outlining their basic proportions rather than the details, since a simple outline creates a stronger impact.

5.
To sketch the female figure, again begin where the hands link. Look across to get the proportions correct: for example, the man's navel lines up roughly with the woman's left nipple.

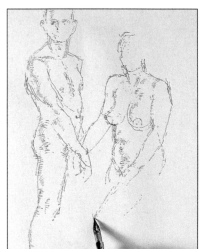

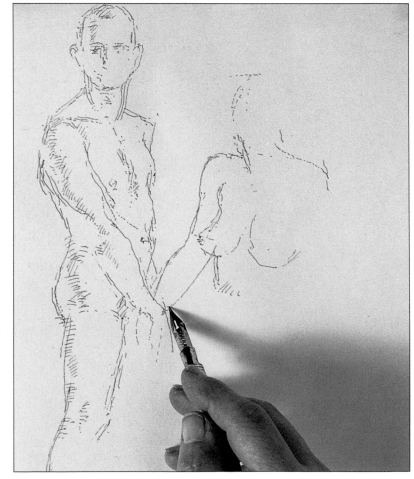

6.
Use the straight edge of a pencil to establish the position of the woman's knee: it lines up vertically with the edge of her right hand, and horizontally with the man's knee.

7.

Great care should be taken when
drawing the legs and knees because
of the 'negative', undefined space
between the two figures. If this
space is disproportionately large or
small, the figures will not look
natural. To avoid problems, do not
develop one body area too far ahead
of another, but build up the features
gradually together.

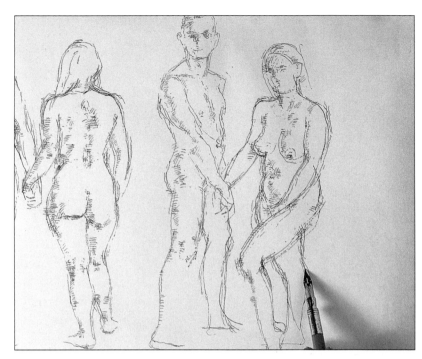

8.

Once the outlines are complete,
pick out the detail and increase the
definitions. Make sure the two sets
of figures match in tone and style:
observe the thickness of the lines
and work out which features have
been emphasized.

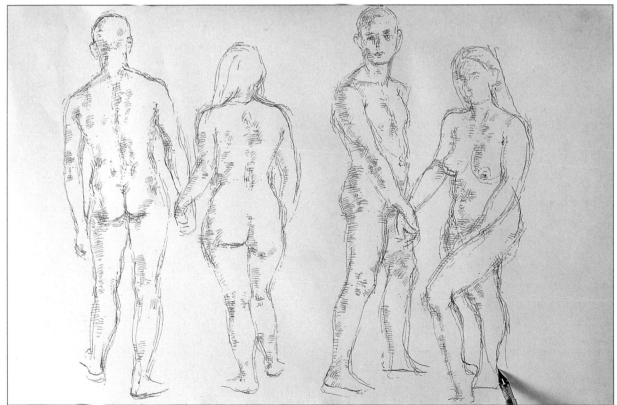

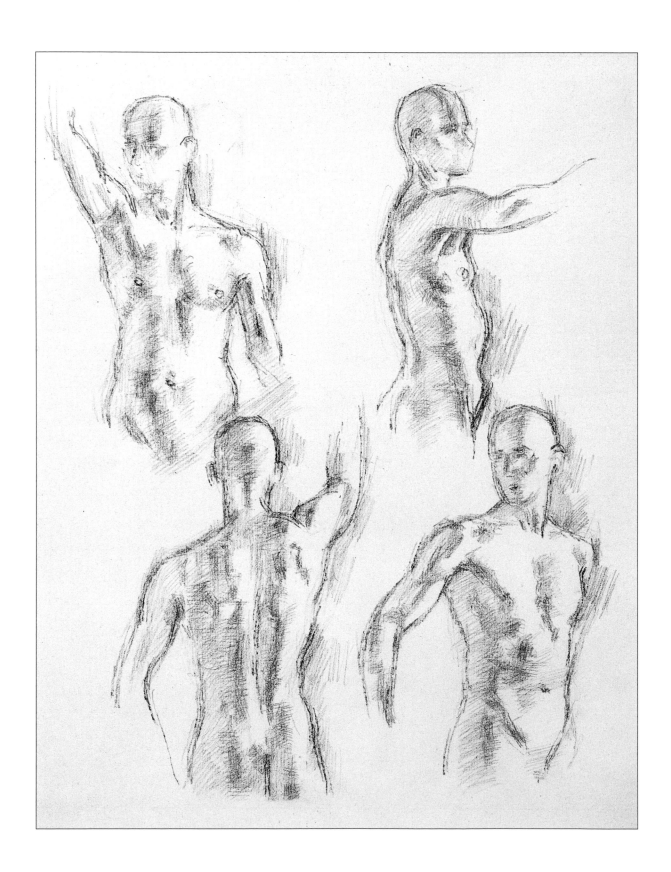

MALE TORSO

In this carefully observed study the artist provides a simple but comprehensive image of the male torso with a series of pencil sketches from front, rear, side and twisted positions. The four views allow the artist to explore the various surface muscles on the chest, shoulders, neck and back simultaneously through using lines and shading built up with a combination of lighter and darker strokes. Generally, the style of shading is loose to suggest the outline of the form and convey a sense of movement. The four illustrations should be viewed as a single composition, and as such, they should be of a proportionate scale and highlight the same parts of the male anatomy.

James Horton
Four Studies
30 x 20cm (12 x 8in)
Pencil

Upper Body Muscles

In order to keep the arm raised, the latissimus dorsi must be extended. With the head turned to one side, the sternocleidomastoid muscle in the neck becomes very prominent – this is especially noticeable on the first and last photographs. A deep furrow is formed on the front of the body, caused by the sternum (breast bone) and the rectus abdominis muscles (stomach). On the rear view, an even deeper furrow down the spine is created by the powerful erector spinae muscles. The pectoralis muscles, by contrast, appear as flatter expanses of flesh.

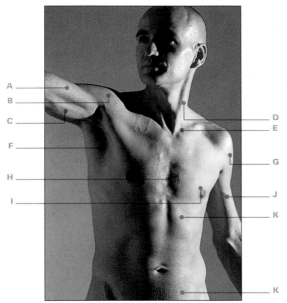

Above: A biceps, **B** deltoid, **C** triceps, **D** sternocleidomastoid, **E** clavicle, **F** latissimus dorsi, **G** deltoid, **H** sternum, **I** pectoralis, **J** biceps, **K** rectus abdominis

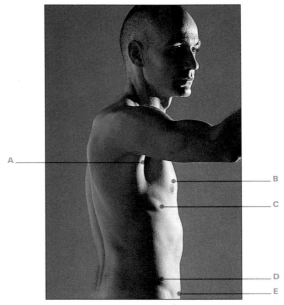

Above: A latissimus dorsi, **B** pectoralis, **C** serratus anterior, **D** external oblique, **E** rectus abdominis

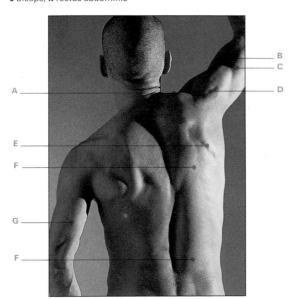

Above: A trapezius, **B** biceps, **C** brachialis, **D** deltoid, **E** scapula – showing rotation over ribcage, **F** erector spinae, **G** triceps

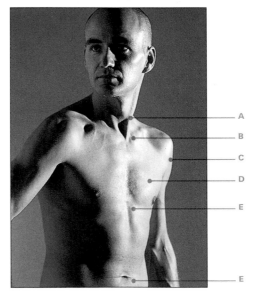

Above: A sternocleidomastoid, **B** clavicle, **C** deltoid, **D** pectoralis, **E** rectus abdominis

FOUR STUDIES

1.

First, roughly position each pose on the page. Lightly sketch in the top left pose first – start from the head and work down the body. Once you have sketched in the first figure, check the scale to see if all four figures will fit. Take your time, as even experienced artists have difficulty calculating the correct scale. You can also overlap the images as a way of linking them together.

<div style="float:left">

</div>

<div style="float:right">

Materials and Equipment

- BLACK BEAUTY PENCIL
- ZERKHAL INGRES PAPER
</div>

2.

Sketch in the figures with a series of light, short strokes that overlap – this will create a soft, natural outline. Let your intuition and the shape of the muscles guide you with the shading, which can be vertical, horizontal and cross-hatched. Work in the detail of the sternocleidomastoid, the main muscle connecting the collar bone and the back of the head.

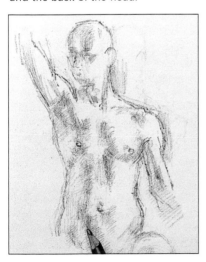

3.

Deepen the shading to show the join between the pectoralis major (the largest chest muscle) and the anterior deltoid (shoulder) muscle. Outline the rectus abdominis, which links the ribcage to the pelvis.

4.

Now move on to the third figure. Begin by shading the back of the head to show the roundness. There are several layers of muscle on the back, some of which appear as surface features. You can begin to shade in the trapezius.

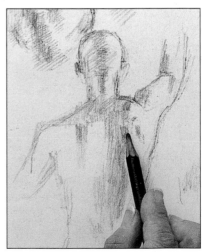

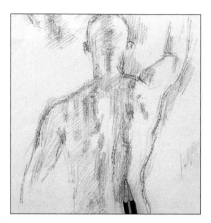

5.

Using vertical shading, emphasize the ridges of the erector spinae down each side of the spine, all the way from the pelvis to the neck. Many of the other back muscles are sheet-like and should be highlighted with shading. Light, diagonal strokes along the outside of the body will suggest the shape of the latissimus dorsi, while a heavier line under the arms will emphasize the teres major.

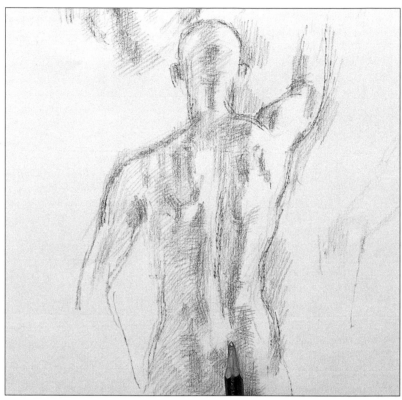

6.

Add the final detail, deepening the shading. Sketch a very light line down the centre of the back to bring out the posterior median furrow. Leave areas of the paper untouched to emphasize the areas of light. You can also sketch in the beginnings of the gluteus medius (buttocks).

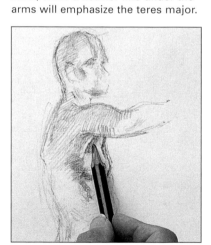

7.

Now move on to the third picture. First define the head (note that it is turned slightly to the right). This side-on pose shows the construction of the armpit, which is formed by the angle of the latissimus dorsi and the pectoralis major.

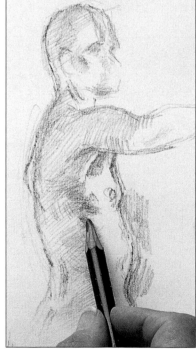

8.

Down the side of the body there is quite a dramatic contrast. Using some heavy strokes, define the serratus anterior muscles, which are the most heavily shaded part of the abdominal muscles. Lightly shade the shoulder and latissimus dorsi to provide definition. Also, a little background shading will help emphasize the body line.

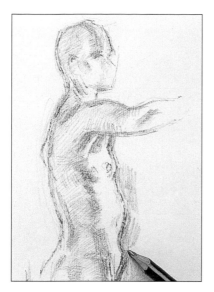

9.

Using light strokes, increase the shading down the back to show the definition between the front and back. Sketch in the buttocks, to link in with the second picture and bring the composition as a whole together.

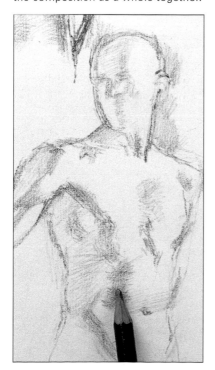

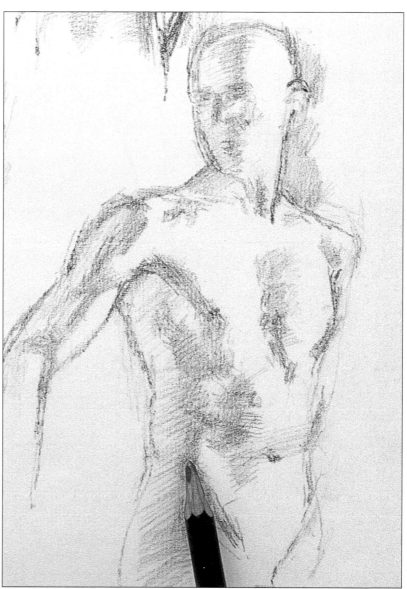

10.

Sketch in the head, using a clear line to mark the sternocleidomastoid and to demonstrate that the head is turned. Shade along the top of the arm to give good definition to the biceps. Lightly shade in the edge of the pectoralis major, cross-hatch the serratus anterior, and very lightly shade the outer edge of the body to show the latissimus dorsi.

11.

Darken around the rectus abdominis – vary the angle of the shading to emphasize the different muscles in this group. Shade in the head, suggesting the features rather than drawing in detail. Shade in the line showing the external obliques along the front of the pelvis. Remember that loose shading adds a sense of movement to the composition.

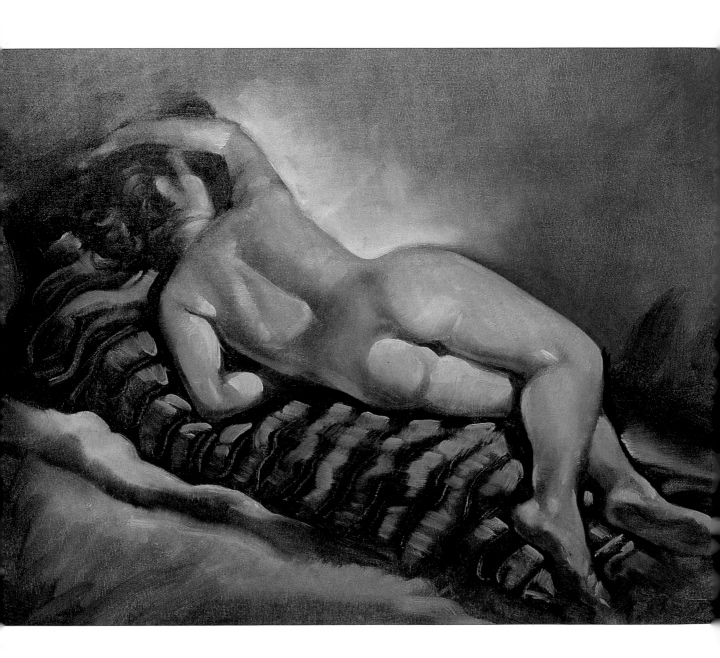

FEMALE RECLINING

In this carefully observed painting the artist makes great use of light and shadow to pick out the surface anatomical details of the subject. This also adds a pleasing variation of tone to the flesh. In this position the weight is distributed along the body and the muscles are in a relaxed state. This results in much smoother forms and lines. The dark background and foreground help to highlight the figure.

John Barber
Nude Study
30 x 40cm (12 x 16in)
Oil Paint

Relaxed Pose

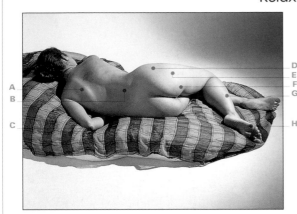

In this position, the pelvis is at a right angle to the horizontal. The thorax, however, sinks back into the mattress leaving the pelvis standing proud. This accentuates the angle from hip to ribcage. Because the arm is pushed under the thorax, the shoulders tilt at a different angle to the pelvis. This means that at the start of the thoracic vertebrae the spine begins to not only move upwards but also forwards.

Left: **A** scapula, **B** start of thoracic vertebrae, **C** ulna, **D** crest of pelvis, **E** tensor fascia latae, **F** gluteus maximus, **G** gastrocnemius, **H** abductor digiti minimi

NUDE STUDY

1.

Prepare the canvas with a thin coat of raw umber. Use a round number 3 hog brush to mark in the basic shape of the figure in raw umber. Use the paint fairly thin; the painting medium is turpentine and linseed oil.

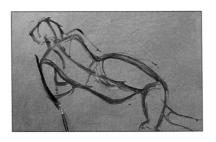

Materials and Equipment

• CANVAS • OIL PAINTS: WHITE, RAW SIENNA, RAW UMBER, ULTRAMARINE BLUE, BLACK • BRUSHES: NO. 3 HOG, NO. 8 HOG, NO. 3 ROUND BRUSH, NO. 4 FILBERT, NO. 12 FILBERT, NO. 3 ROUND, NO. 4 FAN BRUSH, FLAT BRUSH, NYLON/HOG BLENDER, BADGER BLENDER • RAG • PALETTE • PAINTING MEDIUM: TURPENTINE, LINSEED OIL

2.

Use a rag to wipe out any mistakes. Take time to make sure the sketch is right, and don't be afraid to redraw sections of the image. Now start blocking in the shadow areas with more raw umber. Block the shadows in crudely: the dark areas will still tell us about the form. When you are happy with the sketch, use the rag to soften all of the lines.

3.

Mix some raw sienna with white on your palette until you have a warm skin tone. Apply this to all the light areas of the body. The raw umber is still wet, so you may get some mixing. Do not drag the paint once it has been applied so as to avoid it blending with the shadow areas.

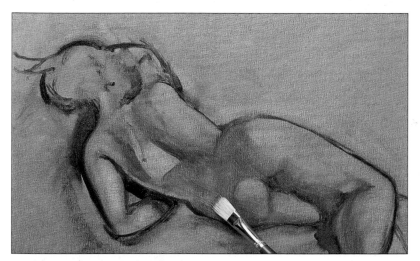

4.

Use a flat brush to apply some more paint to the shadow areas (use the same shadow mixture as before, just a little stronger).

5.

Use a badger blender brush in a flicking action to drag one colour into another. This takes away the hard edges and leaves you in a good position to redefine the form.

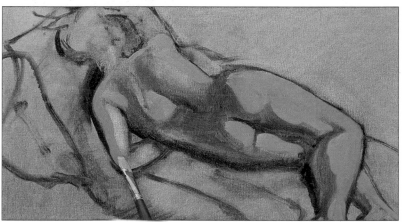

6.

Add more white to the skin tone mixture. Look for areas that have to be lightened. Use a number 8 hog brush, but don't add too much white too early. Use broad brush strokes to map out the overall plan.

7.

Use a badger brush to drag light paint into the shadows and give a sense of form to the body. Try to graduate the edges of the light and dark areas. Now use a nylon or a hog blender brush to tone off the backlighting on the lower thigh and the top of the lower arm.

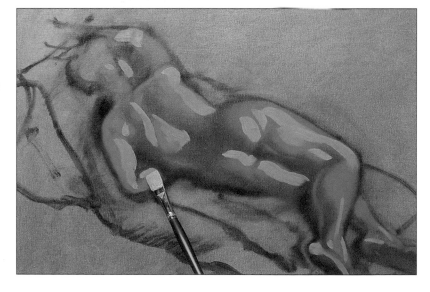

8.

Mix ultramarine blue with black. Use a flat brush to apply this as a working background colour. Use the corner edge of the brush to mark in the outline of the thigh.

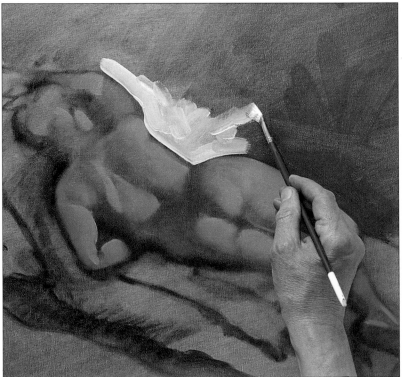

9.

Now mix white with a little bit of background colour. Use a number 4 filbert brush to define the flesh against the background. Half close your eyes to decide where dark and light define the edge of the body.

10.

Now use a number 3 round brush to touch in brighter colour to the highlights on the body. Avoid overdoing this, as the skin might end up looking polished – it should have a matt appearance. Now use a blender brush to ease the light paint into the surrounding areas. Follow the form of the body with the brush.

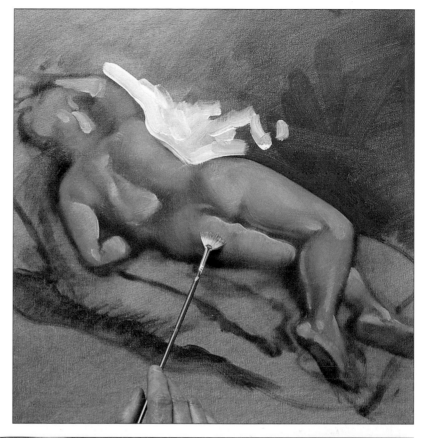

11.

Use a blender brush to tone down the background and create a gradation of light around the body. Use the paint already on the canvas and move it around with flicking actions of the blender brush.

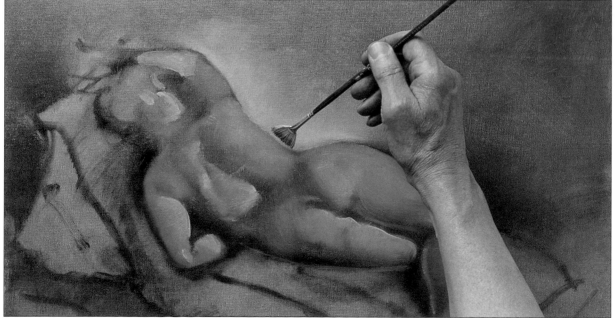

12.

Use a number 12 filbert brush to apply a mixture of ultramarine blue, black and raw sienna for the striped material the model is lying on. Ignore the stripes at this point and just cover the whole area. Start by carefully following the outline of the body as it comes into contact with the striped material.

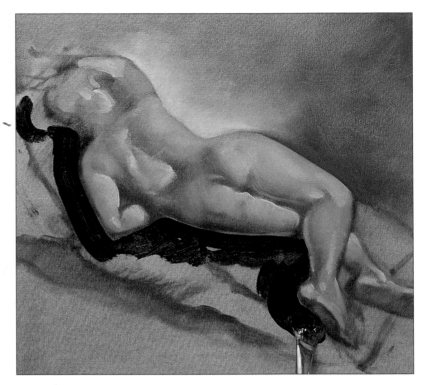

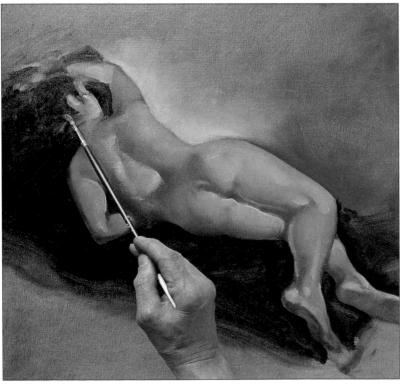

13.

Add black to the blue background colour to mark in the hair with a number 3 hog brush. Use pure black on the parts that you want to look glossy where the light reflects, and then use a blender brush to create a proper sense of form.

14.

Create the stripes by wiping paint off with a rag. Use ultramarine blue and raw sienna to highlight the stripes and accentuate the creases.

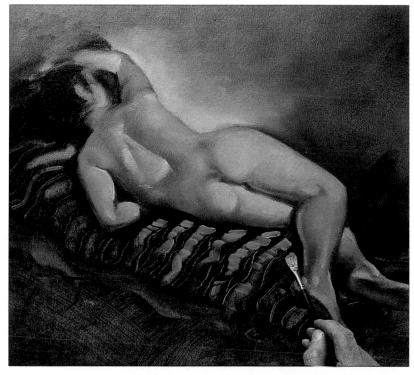

15.

Use a flat number 8 hog brush to mark in the white of the cloth in the foreground. Now return to the figure using a number 4 fan brush to go over the lightest areas once more, accentuating them.

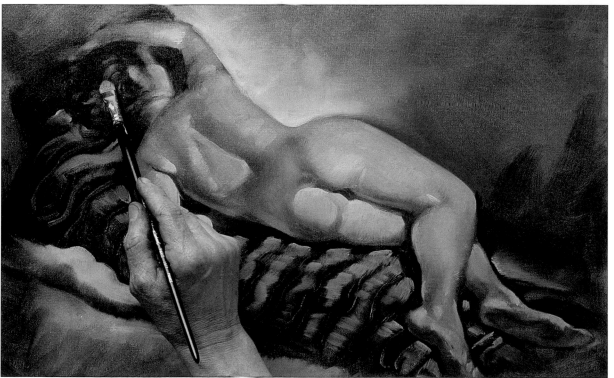

ATHLETE

The figure used in this project is focused and ready for action. Muscles and tendons are in a state of tension, and the whole body seems to point in the direction the runner is about to go. Here the anatomy tells an important part of the story of the picture, as the muscles and tendons display the fact that the figure is ready for movement. The arm in the foreground is especially effective in this role, and the artist highlights this area by making the muscles and tendons evident, to enforce the idea of imminent forward motion.

John Barber
Tensed Muscle Study
38 x 56cm (15 x 22in)
Watercolour

Observing Muscle Tension

In this project the aim is to show tension, the sort of tension that is used just prior to forward propulsion. What is also essential to this position is balance. Here the artist needs to observe and place each limb very carefully or the figure will not balance correctly. The use of horizontal and vertical measurements would be useful in this pose to check on the angle of the limbs. It is also a perfect position for using the negative shapes that exist between the legs and arms to gain extra accuracy.

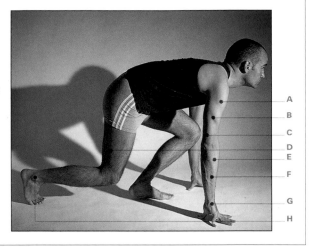

Right: **A** deltoid, **B** triceps brachii, **C** tendon of triceps, **D** vastus lateralis, **E** extensor carpi radialis longus, **F** extensor carpi ulnaris, **G** ulna, **H** lateral malleolus (fibula)

TENSED MUSCLE STUDY

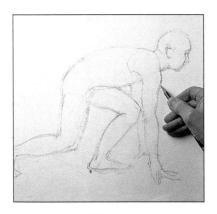

1.

Sketch in the outline of the figure with a graphite pencil. Place the figure in the centre of the paper, with about 2.5cm (1in) outside the drawing to the edge of the paper. This allows for lengthening of the limbs if you make an error in your initial proportions. Note that where the tendons are close to the surface, the outline is quite straight, whereas muscle creates curving shapes.

Materials and Equipment

• ROUGH SURFACE, 120 LB WATERCOLOUR PAPER
• GRAPHITE PENCIL • BRUSHES: ¼ INCH FLAT NYLON, 1½ INCH FLAT NYLON, NO. 10 SABLE
• WATERCOLOUR PAINTS: YELLOW OCHRE, LIGHT RED, VIOLET, RAW SIENNA, BURNT SIENNA, PRUSSIAN BLUE
• PALETTE • TISSUE

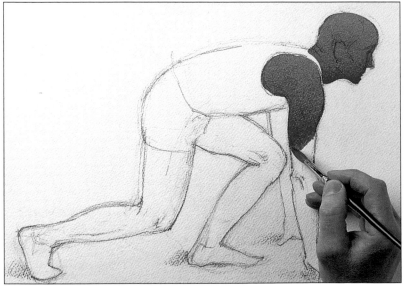

2.

Mix yellow ochre and burnt sienna (slightly more sienna than ochre). Apply this in a flat wash over the flesh areas of the body. Use a number 10 brush with a good point.

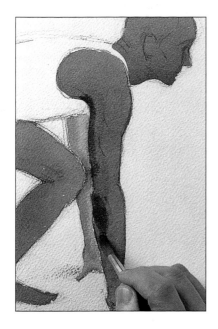

3.

Add a little raw sienna to the mixture and use this to touch in the shadows. Do this while the first wash is still damp.

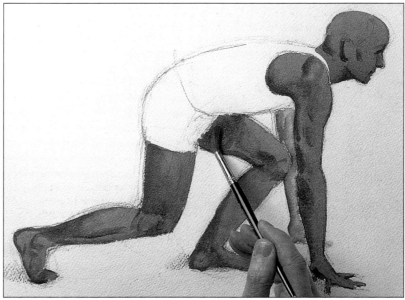

4.

Add some raw sienna to make a deeper tone for the darkest areas of shadow. Apply this to the groin area.

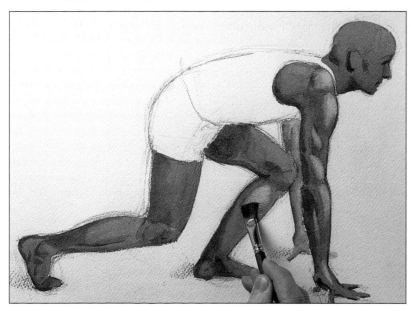

5.

Use a clean ¼ inch flat nylon brush with a flat head dipped in clean water to lift out areas of paint for the highlights. Gently stroke the surface with the wet brush and then blot the area with tissue.

6.

Continue adding highlights until the variations of light and shade give a good impression of the general anatomy of the figure.

7.

Mix a weak wash of Prussian blue and violet for the shorts. Apply this to the whole area and then lift out paint for the stripes and the creases. Use pure Prussian blue for the running vest, blocking in the colour over the whole area.

8.

While the paint for the vest is still damp, dab more colour into the area and tilt the paper so that darker paint runs where you want it, creating shadows on the material. Use raw sienna with a little Prussian blue for the cropped hair.

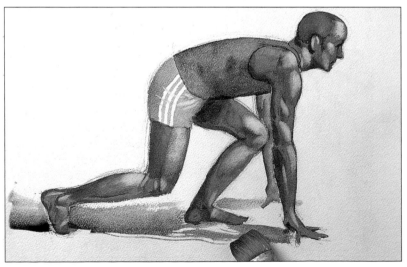

9.

Use Prussian blue with a little violet and light red and lots of water for the shadow under the figure. Let the paint run up to the edge of the area to create a sense of perspective, but try to keep the lines sharp.

10.

Now mix some Prussian blue into the mixture; wait until it is a little dryer, then use it to outline the runner's face and the upper part of his arms.

11.

Now use a 1½ inch nylon brush with lots of water to create the background. Use the wet brush to move the paint already on the page around. Be careful not to allow paint to run back over the figure.

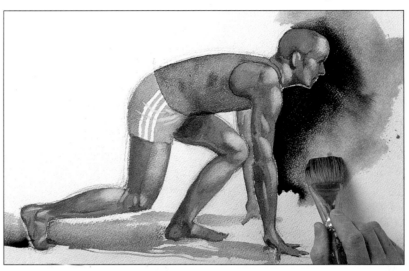

12.

Let the wash go over the legs to focus attention on the arms and face. Finally, add some light red to the area behind the runner.

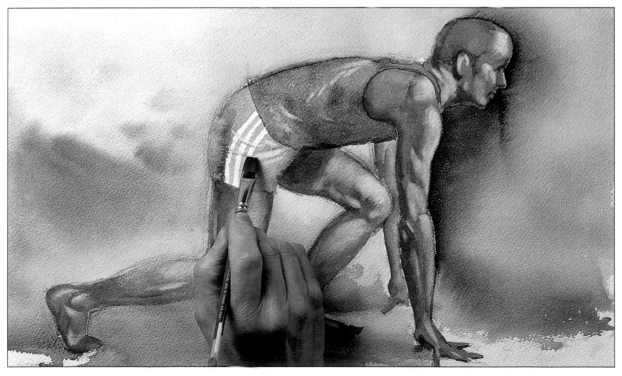

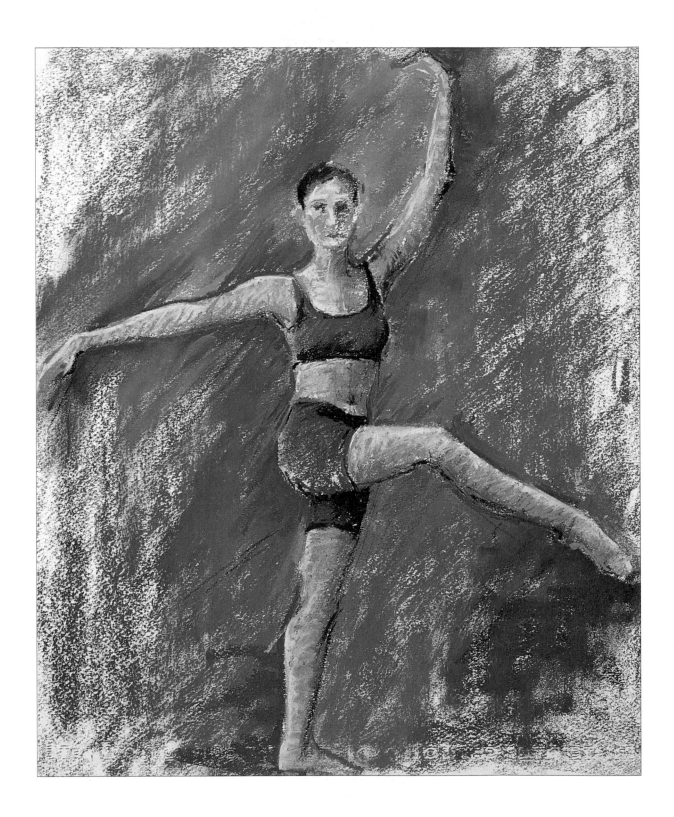

DANCER

The entire weight of the dancer in this project is supported on one leg. Yet she maintains perfect balance while creating graceful shapes with her arms and other leg. This is a study not of the body under tension but of the body used to express grace and poise. An understanding of anatomy is vital here in order to get the proportions of the figure right and to make sure that the pose is recorded correctly. The torso, neck and head are held upright, while the arms and upper leg form curves away from the body. Although the pose looks effortless, muscles and tendons are at work beneath the surface. The artist is careful to pick these out without losing the overall grace of the image.

Charmian Edgerton
Grace
55 x 38cm (22 x 15in)
Charcoal and Pastel

Capturing Poise

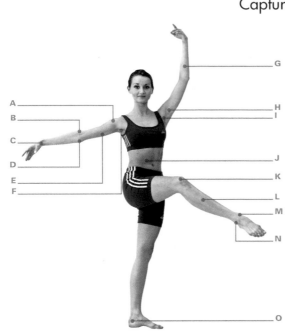

To elevate the arms up to the horizontal position, the deltoid in the upper arm is used. In order to raise the arms above horizontal, the trapezius and serratus anterior come into play. The serratus in particular enables the scapula to rotate across the ribcage, which in this case is almost vertical along the humerus.

To raise the leg into this position the muscle group known as the quadriceps femoris is used. As the upper leg is moving towards the centre of the body there will also be some assistance from the adductor group, including the gracilis muscle. In this subject the muscles provide strength and control. The extended arms and leg help balance the supporting foot.

Left: **A** deltoid, **B** extensor carpi radialis longus, **C** radius, **D** humerus, **E** biceps brachii, **F** lattissimus dorsi, **G** flexor carpi radialis, **H** tendon of biceps brachii, **I** pectoralis major, **J** rectus abdominis, **K** patella, **L** tibialis anterior, **M** medius malleolus, **N** lateral malleolus, **O** Achilles tendon

GRACE

1.

Start by dropping a very faint line in charcoal down the centre of the paper. Sketch in the head and the arms in light charcoal. Make sure you get the proportions right.

2.

Use the head to get the size of the body right: the body is about 6½ times larger than the head. Mark a centre line down the body. Continue to sketch the body and correct mistakes as you go. Smudge some of the lines with your finger to give the impression of movement.

Materials and Equipment

• SMOOTH, WHITE PASTEL PAPER
• CHARCOAL • PASTEL COLOURS:
LIGHT YELLOW, CHROME
YELLOW, BURNT ORANGE, DARK
BURNT ORANGE, BLUE-GREEN,
GREEN-BLUE, ULTRAMARINE
BLUE, PRUSSIAN BLUE, LIGHT
PINK, LIGHT RED, PERMANENT
ROSE, VERMILLION, PINK-VIOLET,
MID-VIOLET, DARK VIOLET,
INDIGO, PURPLE (4, 6, 8), BURNT
SIENNA, VANDYKE BROWN
• TISSUE • PUTTY ERASER

3.

When the figure is outlined, go back and fill in some of the detail. When you have all the elements on the paper, brush off the surplus charcoal with clean tissue. Excess charcoal will interfere with the pastel colour.

4.

Fill in the background with ultramarine blue and blue-green pastel. These two colours will complement the skin tones to be used to colour the figure.

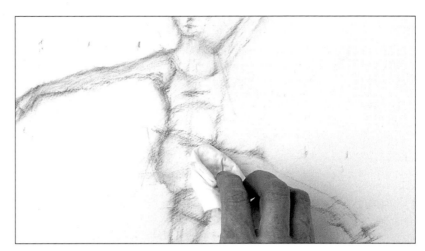

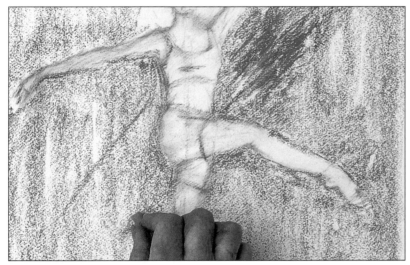

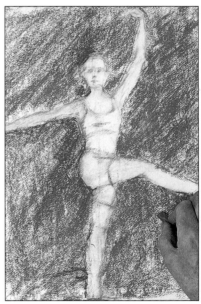

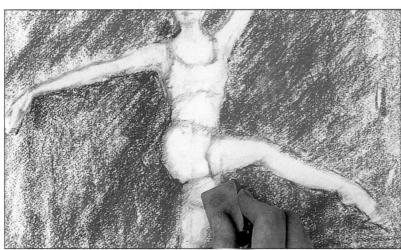

5.

Use the side of the pastels to block in the background colour. Smudge in the two colours lightly.

6.

Use ultramarine blue to block in around the figure. Now use a clean putty eraser to rub out the charcoal lines. Use the eraser as a drawing tool in its own right, following the flow of the body. Don't go over the pastel, as it will just smudge.

7.

Use a very dark purple to colour in the darkest areas of the figure: the top of the head, under the breast, the waist band and the upper thigh of the back leg. Now use indigo to add depth to this tone and put some Prussian blue lightly over the top so that the other colours show through. Now use a lighter purple to colour in the unshadowed parts of the clothing.

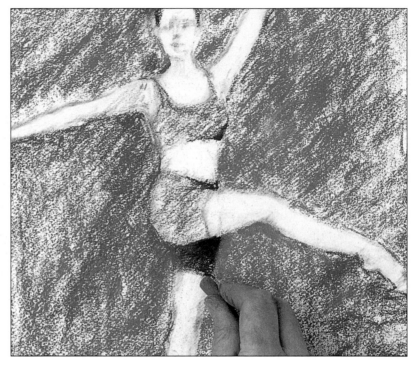

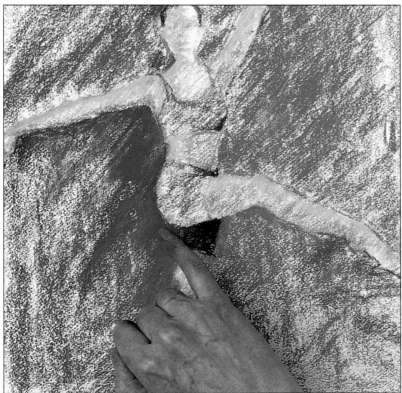

8.

Use a light violet to add the base tone to the skin. Then use a pink-violet pastel to block in the lighter areas and a mid-violet for the mid-tones. Now smooth the background colours around the figure with your finger. This will make the transition between the figure and the colours of the background softer – hard edges will leave the picture lifeless.

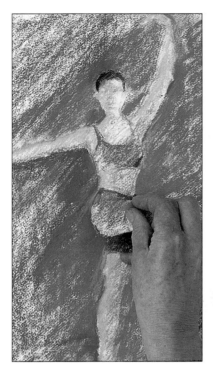

9.

Use burnt sienna for the hair and then pick out highlights with Vandyke brown, light red and permanent rose. Use the last colour to highlight areas of the clothing.

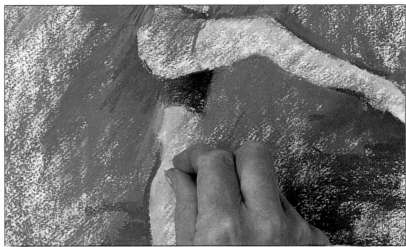

10.

Outline the edge of the figure to emphasize the form. Use a mid green-blue and a mid blue-green. Add some mid green-blue to the background. Use a light pink to enhance some of the highlights on the skin.

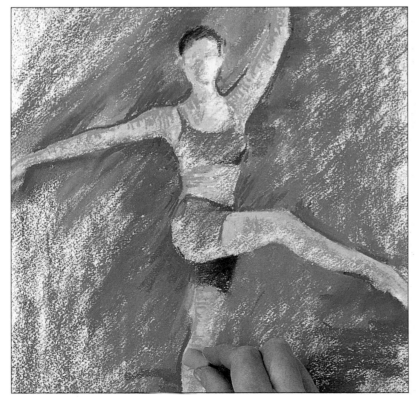

11.

Use burnt orange to start to emphasize the muscles. Work your strokes across the form to show the roundness of the shapes.

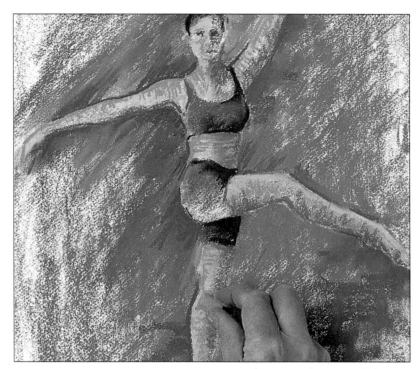

12.

Mark in the eyes with a dark purple. Apply a mid-violet in downward strokes to get a slight cross-hatching effect. Use a dark burnt orange on the underside of the arm, the neck, the underside of the legs and the front of the supporting leg. Add a dark purple to the clothing to show the top of the leg and the shape of the breast. Smudge in the orange tones.

13.

Use a light yellow to accentuate the muscles of the calf, using strong strokes to apply the colour. Continue to accentuate the dark tones with dark burnt orange, particularly the underside of the upper arm and the abdomen. Use some dark violet for the top of the upper leg.

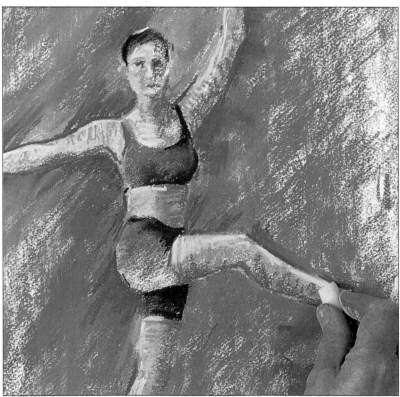

14.

When you approach the completion of the picture do not rub in the colour too much, as this will give the image a flat look. Add the final touches to the background by putting in a few lines of burnt sienna. This will chime with the colours used in the figure.

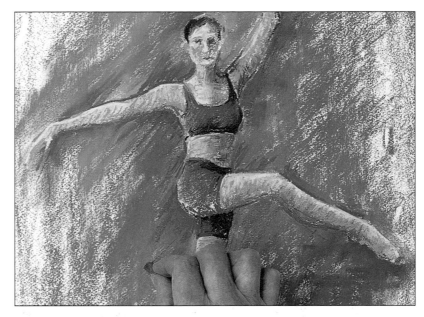

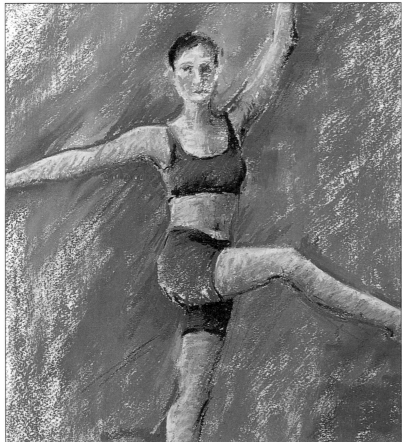

15.

Now mark in the final detail. Use vermillion red and chrome yellow to exaggerate some of the muscles in the stomach area. Use indigo for the navel and for the vertical muscle lines. Vermillion brings warmth to the shadow on the legs as well as to the buttock area.

INDEX

The author and publishers would like to thank the following for permission to reproduce additional photographs:

The Art Archive pages 6-9

We would also like to thank the models that feature in this book: Konstantina Koulkolitsa, Rose Nightingale and Nick Upton.